LEGENDARY LOCALS

OF

WEST PALM BEACH

FLORIDA

Date: 2/17/16

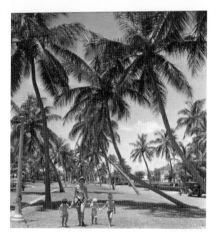

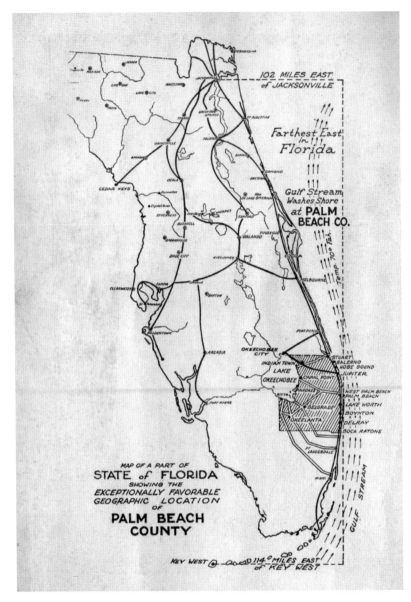

Florida in 1920

This 1920 map depicts a much less populated Florida and Palm Beach County. Florida was known for its agricultural attributes, and local chambers of commerce touted the sunny, warm winters as ideal for farmers. This map lists "Belgrade" instead of the correct Belle Glade as the westernmost town in Palm Beach County. (Authors' collection.)

Page 1: **Florida Avenue in the 1940s**

This idyllic scene captures the beautiful coconut palms in the Grandview Heights neighborhood, one of West Palm Beach's earliest planned developments. The neighborhood has excellent examples of different architectural styles, from simple frame houses to large Mediterranean Revival homes. This image is found on page 32. (Courtesy of the State Archives of Florida.)

LEGENDARY LOCALS

—— OF ——

WEST PALM BEACH

FLORIDA

JANET M. DEVRIES AND GINGER L. PEDERSEN
FOREWORD BY DEBI MURRAY

Legendary Locals is an imprint of Arcadia Publishing
Charleston, South Carolina

Printed in the United States of America

Library of Congress Control Number: 2015938225

For all general information, please contact Arcadia Publishing:
Telephone 843-853-2070
Fax 843-853-0044
E-mail sales@arcadiapublishing.com
For customer service and orders:
Toll-Free 1-888-313-2665

Visit us on the Internet at www.arcadiapublishing.com

Dedication
Dedicated to the pioneers of the Lake Worth Country whose bravery, hard work, and vision created the veritable paradise we now call West Palm Beach.

On the Front Cover: Clockwise from top left:
Hank Aaron, baseball player (courtesy of the *Palm Beach Post*; see page 38). Kay Rybovich, IWFA founder (courtesy of Kay Rybovich; see page 76), Grace F. Morrison, secretary and aviation promoter (courtesy of the Historical Society of Palm Beach County; see page 74), Burt Reynolds, actor (courtesy of Palm Beach State College; see page 56), Mary Brandon, moving company founder (courtesy of Susan Miller; see page 59), George Hamilton, actor (courtesy of Angela George under Creative Commons, CC by SA3.0; see page 52), Gary Carter, baseball player and coach (courtesy of the *Palm Beach Post*; see page 38), Billy Bowlegs, Seminole tribe leader (courtesy of the Library of Congress; see page 11), and Dickey Betts, musician (courtesy of Todd Gay; see page 54)

On the Back Cover: From left to right: Marion E. Gruber's hardware store (courtesy of the Historical Society of Palm Beach County), and Paul Dreher (courtesy of the Palm Beach Zoo).

CONTENTS

FOREWORD

The city of West Palm Beach, the oldest town in Palm Beach County, incorporated in 1894, two years before Miami, and had unique beginnings. It did not grow organically, as so many cities did, starting perhaps at a busy crossroads that may have had a tavern and a livery serving travelers, with new businesses planting themselves nearby as needs arose. West Palm started as a fully platted community, with clearly delineated business and residential areas. The municipality also had one other beneficial component—Standard Oil magnate Henry Morrison Flagler as its founder.

Flagler purchased what became the original townsite in 1893, paid to have it surveyed and platted, and encouraged entrepreneurs to settle and open businesses there. By the summer of 1894, enough people were living along the new roads to start discussions about becoming an incorporated town, and in November, it became a fait accompli. Over the next two decades, Flagler helped the bustling metropolis by donating land for government buildings, churches, and schools and providing matching funds to construct those buildings. Otherwise, he left the town's commissioners to conduct business as they saw fit.

Individuals and families came to West Palm Beach from across the country and around the world to take advantage of the opportunities it offered. No longer could this part of South Florida be considered a neglected outpost far from civilization, and even though it was literally at the end of the new railroad line, people saw it as the beginning of far greater things to come.

That sense of infinite possibility continued to lure new residents for decades (and in many ways still does), allowing West Palm Beach to grow exponentially, far exceeding its original borders. Authors Janet DeVries and Ginger Pedersen had thousands of people to choose from for this book. However, many could not be included because all that is left of their lives are the oral traditions—no photographs could be located. Hopefully, readers will help historians and history organizations save evidence of their lives by donating archival materials and artifacts so that they can be accessed by future generations—and perhaps included in the next publication.

—Debi Murray

ACKNOWLEDGMENTS

Many people and organizations shared information, photographs, and ideas for *Legendary Locals of West Palm Beach*. The authors are deeply indebted to all those who took an interest in the project and contributed to the book. The Historical Society of Palm Beach County and the *Palm Beach Post* archives provided many interesting photographs from their collections. Historian and chief curator Debi Murray provided invaluable content editing suggestions; Michelle Quigley, news researcher at the *Palm Beach Post*, guided us to photographs taken by some of the newspaper's best photographers. Harvey E. Oyer III shared his expertise of history and community ties. Researching and gathering images for this history book about local personalities proved to be an enjoyable and enriching process in part due to crowdsourcing from various social media groups, including I Grew Up in the Palm Beaches in the 1960s, 1970s, and 1980s.

We thank Arcadia Publishing acquisitions editor Erin Vosgien for her helpful suggestions and for keeping us on a tight production schedule. The following list includes some of the people who assisted us in obtaining images or led us to interesting stories. We apologize for any names omitted from the acknowledgements; we met so many interesting people on our journey to illuminate some of the legendary locals of West Palm Beach.

Many thanks to Greg Allikas, Patricia Alvarez, Jennifer Anthony, Steve Anton, Steven Baker, Joan Beach, Susie Rambeau Best, Bridget DeVries, Vetatur Fumare, Kristin George, Nicholas Golubov, Larry Grosser, Maggie Houlehan, Theresa J. Hume, Eliot Kleinberg, Angela Ledford, Pete Lyons, Peggy McBride, Kari McCormick, Sara Mears, Susan Miller, Kimberly Mitchell, Friederike Mittner, Penny G. Murphy, Michael P. Naughton, Jan Norris, Brandon Orlando, Paul Pickel, Jim Pike, Greg Rice, David Spero, Earl Stewart, Adam Watson, and David Willson.

INTRODUCTION

The word frontier has always been an important part of the American psyche. America's last frontier was South Florida, most of it a swamp teeming with alligators and mosquitoes. A few pioneers had attempted to settle in the 1840s through the Armed Occupation Act, but South Florida's unforgiving climate and remoteness was a tough nut to crack, and the settlers left.

It was a different kind of nut that propelled the area into its eventual fame. As a few settlers homesteaded around Lake Worth, the 22-mile-long lake now commonly called the Intracoastal Waterway, a shipwreck changed history. The *Providencia*, a Spanish brig loaded with 20,000 coconuts, wrecked off the coast. The settlers planted thousands of coconuts, and within 10 years, the area was a South Seas–like paradise, and the name Palm Beach emerged. A few pioneers lived on the west side of the lake, but most residents were living on the east side in Palm Beach.

Word began to spread about the tropical paradise, and a few wealthy part-time residents began to spend a winterless winter on the island. Henry M. Flagler, the Standard Oil magnate, visited in 1892. Flagler had built grand hotels at St. Augustine and Ormond Beach, but had not ventured to South Florida. Flagler's visit would prove to be a seminal event in South Florida history. He bought land on both sides of the lake. When Flagler announced he would build the Royal Poinciana Hotel and bring the railroad, a new town was needed that would be a service town for the new resort. Most expected this new town to be called Flagler, but since the area had always been called the "west side," West Palm Beach became the name. On November 5, 1894, the townspeople voted for incorporation 77-1. The one-square-mile town was platted with streets named for plants, with its business district on Clematis and Banyan Streets. The town's earliest nickname was the Cottage City.

So began the town of West Palm Beach. After Palm Beach County was formed from Dade County in 1909, growth continued through the tumultuous 1920s, with the land boom and then utter destruction in the 1928 Okeechobee hurricane. Surviving the Great Depression and continuing through World War II, it was the time between the 1950s and 1970s in which the city's transformation occurred. Through westward expansion, developers drained land and allowed the city to grow to its present size of 58 square miles, with a population of over 100,000.

The people profiled in this book are those who helped shape West Palm Beach's history and who developed its role as Palm Beach County's seat of government and commerce. These stories, some of simple folk who made a difference, others relating how local people made their mark on the national scene, are of a South Florida that still beckons with its signature coconut palms, a land fanned by mysterious, spice-laden breezes. Let this book capture a bit of that breeze that still blows over its residents and visitors.

CHAPTER ONE

The Pioneers Tame America's Last Frontier

As West Palm Beach emerged from the sand pine and scrub oak woods along the coastal ridge, the pioneers who had already homesteaded around the Lake Worth lagoon, along with new settlers, provided the goods and services needed by the emerging community and its resort sister town, Palm Beach. Many of the early townspeople could see the potential in the unique subtropical environment, so they focused their efforts on cultivating tropical fruits such as mango, guava, and pineapple or on vegetable farming during the winter months. Others concentrated on retail establishments, construction, or land speculation. The Seminole Indians were also common visitors to the town, trading deerskins, venison, and huckleberries in exchange for staple items.

The town also saw hotels pop up, albeit on a smaller scale than the grand Royal Poinciana Hotel in Palm Beach. These were modest cottage hotels, typically built in a Victorian style of wood with gingerbread features and octagon towers. The center of commerce was, as it is today, Clematis Street. Resembling an old Wild West town, it featured businesses, hotels, and restaurants. Town officials limited saloons to nearby Banyan Street, where the locals and tourists could drink, visit a billiard hall, or patronize a brothel. Things got a bit too wild, prompting a visit from radical temperance activist Carrie Nation.

The town's infrastructure continued to improve. The sandy streets were difficult to pass, and city leaders surfaced them with shell rock. Workers installed water pipes downtown, and soon the twinkle of electric lights and locally made ice were the results of the first power plant. People came from the North and from other parts of Florida to seek their fortune in the developing settlement, and soon West Palm Beach was on the map.

A.P. "Gus" Anthony, Department Store Founder
The first Anthony's store opened in 1895 in the Palms Hotel on Clematis Street, using a single counter in the post office. Gus Anthony came from Titusville, following Henry Flagler's rails to the world's largest resort hotel, the Royal Poinciana Hotel in Palm Beach. Anthony's invented the dapper Palm Beach look—navy blazer, white pants, white shoes, and a straw boater hat. In 1920, Anthony's opened its flagship three-story store on Clematis Street. With a chain of 13 stores throughout Florida, Anthony's is still going strong, offering women's fashions with a tropical flair. (Courtesy of the Historical Society of Palm Beach County.)

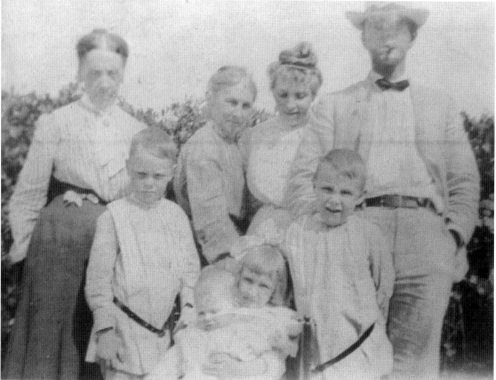

John B. Beach, Horticulturist and Nursery Owner
Hailing from Rome, New York, John Bloomfield Beach first arrived in Florida in 1885 at the age of 19, seeking a warmer climate for arthritis. He started a nursery business on Merritt Island on the Indian River. After the great freeze in 1895, Beach relocated from Melbourne to West Palm Beach. He sold mango trees, pineapple plants, crotons, coconut trees, and other fruit trees from his nursery and developed innovative techniques such as seed-grafting avocados and inarching mango trees. Bloomfield Drive near Southern Boulevard was named for Beach's son who died at age 12; the family owned 40 acres in that area. Pictured here are, from left to right, (first row) Bloomfield Beach, Stafford Bacon Beach, cousin Mildred, and John Bernard Beach; (second row) Elizabeth Bacon, Clementine Ross Bacon, Anne Bacon Beach, and John Bloomfield Beach. (Courtesy of Joan Beach.)

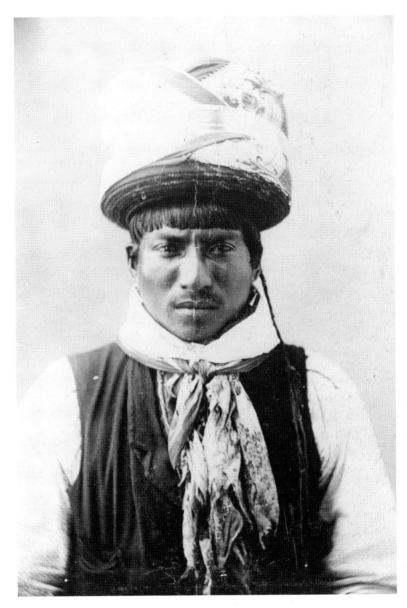

Billy Bowlegs, Seminole Tribe Leader
As a Seminole tribe elder, Billy Bowlegs, seen here in the 1890s, was part of the South Florida scene for more than a century, from its pioneer days to the Space Age. His grandfather was the famed Seminole leader Osceola. Bowlegs was born as Billy Fewell in 1862; the Seminole renamed him at the age of 15 at the spring green corn dance as Billy Bowlegs. Bowlegs and other Seminoles were frequent visitors to West Palm Beach. They traded venison, huckleberries, alligator hides, and deerskins with the settlers and later sold small dolls made of palmetto fiber and brightly colored clothing. Bowlegs attended the opening of the first store on Clematis Street in 1894 and saw Henry Flagler's train pulling in for the first time at the station that same year. Bowlegs was a fixture at the Seminole Sun Dance, a yearly festival held for decades along the waterfront in Flagler Park. Bowlegs lived to be 103, and took his first airplane ride at age 100. When asked if he enjoyed it, he responded, "Fine—fly like bird." (Courtesy of the Library of Congress.)

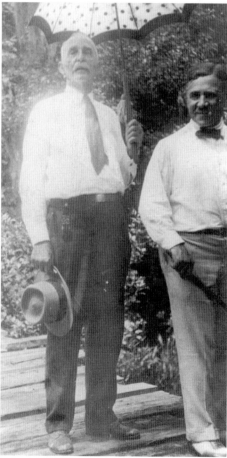

The Burkhardt Family

The Burkhardt brothers, Louis and Henry, arrived from Philadelphia and bought land in the area of present-day Lantana. They were commuters, traveling via boat to their store at Brelsford Point in Palm Beach. The Burkhardts moved the store to Clematis Street, where it became the Pioneer Grocery. The Burkhardts built a large home on the lake in West Palm Beach, seen here in 1895 with the Royal Poinciana Hotel in the distance. Louis Burkhardt served as an alderman and mayor of West Palm Beach. The family is still active in the community; Burkhardt Construction is a leader in urban revitalization. (Courtesy of the State Archives of Florida.)

George W. Lainhart, Hardware Store Founder

As many early pioneers did, George W. Lainhart (left) came to the area from Titusville, accompanied by his brother William. Lainhart's talents were many, with construction his specialty. He built Robert McCormick's house, Lac-a-Mer, which stands to this day as the Sea Gull Cottage. Together with George W. Potter, Lainhart went into the lumber business as Lainhart & Potter, founded in 1894 and finally sold in 2012, thus ending West Palm Beach's oldest family-run business establishment. (Courtesy of the Historical Society of Palm Beach County.)

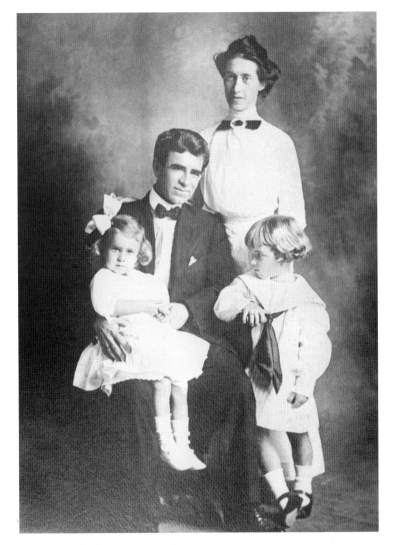

George Graham Currie, Lawyer and Poet

Lawyer by trade, poet by heart, George Graham Currie was West Palm Beach's Renaissance man. Hailing from Canada, Currie stopped in the area on his way to Cuba and ended up staying. He read law and passed the Florida bar exam, and soon the young attorney was serving clients. In 1902, he married Irene Rickards, daughter of Boca Raton founder Thomas Rickards. Tragedy ended the marriage; Irene contracted cholera two months after their wedding and died suddenly. In 1907, he married Lulu Angevine, and they had two children, Frances "Banzai" and Imogene. Currie's service as mayor and civic leader during the first two decades of the 20th century continue to resonate in the city. He was instrumental in founding the Palm Beach County Fair, started in 1912 and still in operation a century later as the county's largest event. He discovered noted sculptor Augusta Savage and helped her get an advanced education in New York to propel her career to the national scene. Currie donated land along Lake Worth for the park that still bears his name. He also brought aviation to West Palm Beach when he hired J.A. McCurdy to fly his Curtiss biplane over the area in 1911. Currie's volumes of poetry, much of it based on the natural beauty of South Florida, is embodied in his line of what WPB stands for, "Where Prosperity Beckons." Currie is pictured here in 1912 with his wife, Lulu, daughter, Imogene, and son, Banzai. (Courtesy of the Newell family.)

Byrd Spilman Dewey, Author

Among the area's earliest residents, Byrd Spilman Dewey and her husband, Fred S. Dewey, arrived on the shores of Lake Worth in 1887. Wading ankle-deep on the sandy trails that would become the streets of West Palm Beach, Dewey was the city's earliest author-in-residence. She was the first newspaper columnist in South Florida with her work at the *Tropical Sun*, and penned the 1899 bestseller *Bruno* from her lakeside cottage south of the city. Her later books *From Pine Woods to Palm Groves* and *The Blessed Isle and its Happy Families* describe life in early West Palm Beach. She is seen here in 1918 with her cat Billy. (Authors' collection.)

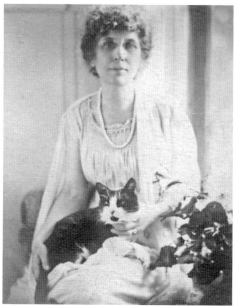

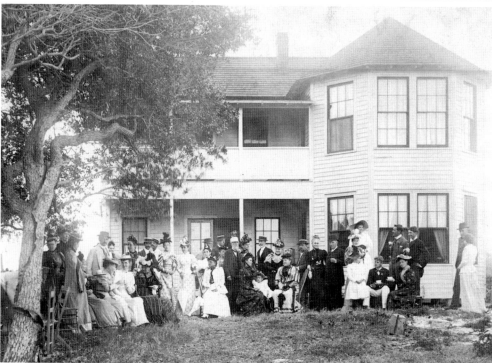

Ben Trovato Tea Party, 1893

The 19-story Rapallo condominium on Flagler Drive now stands over the footprint of the once-grand Dewey estate called Ben Trovato, which means "well invented" in Italian. Many estates such as this ran from what would become the Dixie Highway to the lakefront before the city built Flagler Drive. Here the Palm Beach elite of the 1890s are seen at a tea party given in honor of the new reverend. The Deweys are at far right. (Courtesy of the Historical Society of Palm Beach County.)

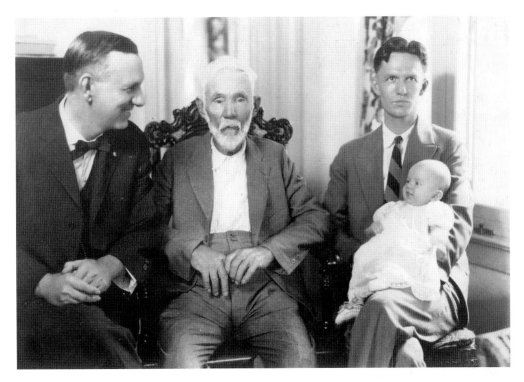

John S. Earman, First Mayor
On November 5, 1894, citizens gathered and voted 77-1 to incorporate as the town of West Palm Beach. The next day, the voters elected John Sites Earman as the town's first mayor. Earman had his home in town and operated a citrus grove farther north, where he started a small settlement called Earman, located near today's Lake Park. John Earman is at center flanked by his son Joseph Lucien (left), grandson John Burke, and great-grandson John Robert. (Courtesy of the Historical Society of Palm Beach County.)

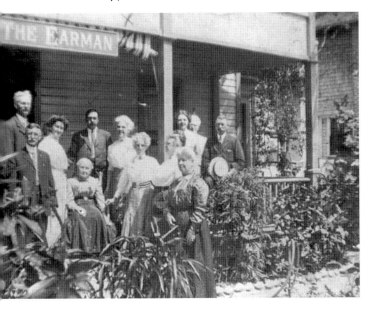

The Earmans
The Earman family is pictured here in the 1890s on the porch of their Frame Vernacular hotel, typical of the pioneer era in West Palm Beach. (Courtesy of the Historical Society of Palm Beach County.)

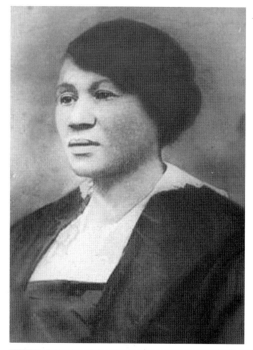

Millie Gildersleeve, Midwife and Nurse
Millie W. Milburn Gildersleeve was among the first African American pioneers to arrive on the shores of Lake Worth, in 1876. She served as midwife for Dr. Richard Potter, who would pick her up from her Riviera Beach wharf to help with home births. She later lived in Pleasant City and continued her private nursing practice. Millie and her husband, Jake, were well respected in the community. Her descendent James "Hank" Harper today serves in the Florida legislature. (Courtesy of the Historical Society of Palm Beach County.)

M. Jacob Gildersleeve, Community Leader
Florida native M.J. "Jake" Gildersleeve married Millie Milburn in the late 1880s; the wedding ceremony was performed on the lawn of Elisha "Cap" Dimick's Palm Beach home. Gildersleeve, a farm hand, laborer, and community leader, was a founding member of the 1893 Tabernacle Missionary Baptist Church and organized Evergreen Cemetery in 1913 with Rev. R.W. Washington, Fred Austin, Robert Holland, Henry Meador, Sam Sharp, and Henry Rhodes. Gildersleeve also served as president of the Evergreen Cemetery Association. (Authors' collection.)

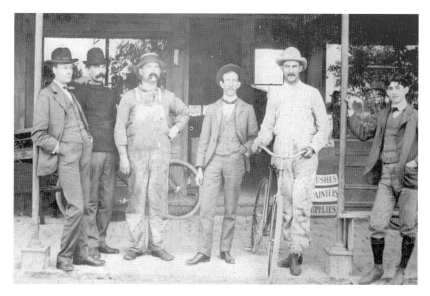

Marion E. Gruber, Hardware Store Owner and Mayor

As many early West Palm Beachers did, Marion Eugene Gruber started his Florida life in Titusville in 1887. After visiting West Palm Beach, Gruber moved his family to the area and started the M.E. Gruber Hardware and Furniture Store on Clematis Street in 1896. The building that housed the hardware store is now listed in the National Register of Historic Places as the Palm Beach Mercantile Company. In 1897, Gruber served as the third West Palm Beach mayor and as tax assessor from 1897 to 1900. Gruber fought hard for Palm Beach County to be separated from Dade County in 1909, and city officials named Gruber as honorary mayor for life. Gruber was an avid baseball fan and is seen below as the manager of the West Palm Beach baseball club. Each local town fielded a team. He also dabbled in the emerging telephone industry, starting with 60 lines. He sold the venture to Southern Bell Telephone in 1919. Gruber is in the center of the top photograph with unidentified townsfolk. (Both, courtesy of the Historical Society of Palm Beach County.)

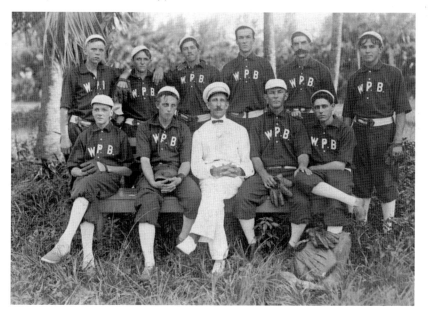

Joseph Jefferson, Actor and Developer

Joseph Jefferson, a man of many talents, spent his last decade in West Palm Beach and Palm Beach enjoying and developing the tropical paradise. Remembered as the most popular stage actor of the 19th century, Jefferson was also an accomplished painter. In his retirement, he could be seen fishing in the inlet, painting, or tending his garden. He spent much time with his close friends including Henry Flagler, Helen Keller, and Pres. Grover Cleveland, a fellow angler. Not only did he electrify the stage in his most famous role of Rip Van Winkle, he truly electrified West Palm Beach in 1895 when he opened the first electric plant and ice plant in the fledgling town. He also developed the Jefferson Block on Clematis Street and the Lakeview Addition south of town, later named the Jefferson Park addition. A street in that neighborhood still bears his name. (Both, courtesy of the Library of Congress.)

Elbridge Gale, Horticulturist
Anyone who has ever tasted a delicious mango can thank Rev. Elbridge Gale. Trained as a horticulturist at Kansas State University, Gale retired to the region that would become West Palm Beach in 1884. He worked with the US Department of Agriculture on different mango cultivars until he successfully grew the Mulgoba variety, which was delectable and grew well in South Florida. That variety started South Florida's mango industry when one of Reverend Gale's seedlings yielded the famous Haden mango. (Courtesy of the Historical Society of Palm Beach County.)

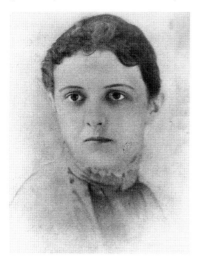

Hattie Gale Sanders, Teacher
At the age of 16, Hattie Louisa Gale, daughter of Rev. Elbridge Gale and Elizabeth Carpenter Gale, taught the first group of students at the settlement's first formal public school. The tiny one-room schoolhouse opened in the spring of 1886 with less than 10 students. Gale married fellow Kansas State Agricultural College student William H. Sanders, who taught at the Mangonia School and worked on Flagler's Overseas Railroad and as a canal-dredging engineer while Hattie stayed home and raised their six children. (Courtesy of the Historical Society of Palm Beach County.)

George W. Potter, Hardware Store Owner and Bank President, and Dr. Richard B. Potter, Physician The many accomplishments of George W. Potter as artist, business owner, developer, and community leader still resonate. Potter and his older brother Richard arrived in Florida in 1874, first settling at Biscayne near Miami. Not finding enough patients for Richard's medical practice, the brothers headed for the Lake Worth Country. George Potter sketched and painted the beautiful scenery, capturing a paradise long since lost. The Potter brothers homesteaded 150 acres of land on Palm Beach, just south of Southern Boulevard. They named the estate Figulus, Latin for "potter." Together with business partner Owen Porter, George Potter formed South Florida's first real estate company in 1883. George Potter's talents with a pencil went to good use as a surveyor and mapmaker, drawing the plat for West Palm Beach in 1894. As the town emerged from the wild woods and saw the arrival of Henry Flagler's train, George Potter started the legendary Lainhart & Potter lumber and hardware company with George Lainhart. George Potter also served among the first city aldermen and was president of Pioneer Bank. Dr. Richard B. Potter was West Palm Beach's first doctor. Dr. Potter was a trusted physician and surgeon of much skill, and practiced all types of medicine, as the nearest hospital was in Jacksonville. The Seminole Indians often sought him out when their healing methods brought no relief, a sign of respect for the doctor and his knowledge. (Both, courtesy of David Willson.)

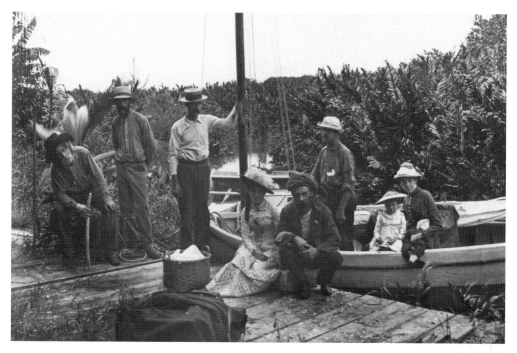

The Potter Family

These photographs are among the earliest taken in the area that would become West Palm Beach. Above, the Potter brothers are seen with other family members and friends at their dock at Figulus. The high vegetation along the shore indicates the area was still an untamed paradise. Below, the Potters and friends stand near the shore of Clear Lake, with a lone cabbage palm emerging from the swamps and lake. (Both, courtesy of David Willson.)

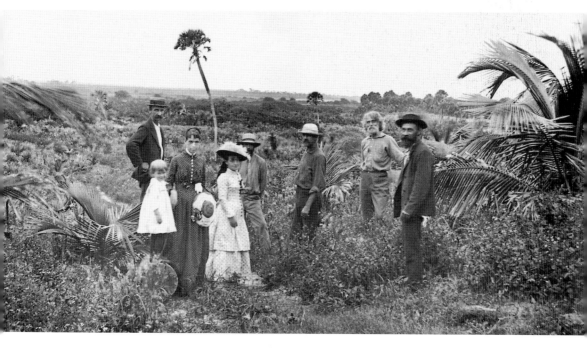

Guy Metcalf, Newspaper Publisher, Developer, and School Superintendent
Guy Metcalf came to South Florida in 1891 with great dreams and a pioneering spirit. He moved his weekly newspaper, the *Indian River News*, to Juno (and later West Palm Beach) and rebranded it as the *Tropical Sun*, South Florida's first newspaper. The newspaper captured the fun and frolic of West Palm Beach's earliest days. Metcalf was instrumental in the erection of the town's first substantial school building, a school that still stands as the Dreyfoos School of the Arts. Through his Tropical Real Estate Exchange Company, Metcalf blazed the first road to Miami through the thick Florida scrub; the Bay Biscayne Line ran between Lantana and Lemon City. He also served as postmaster and superintendent of public instruction. In 1918, Metcalf took his own life in an incident over a $300 draft he took to pay for school equipment. (Courtesy of the Historical Society of Palm Beach County.)

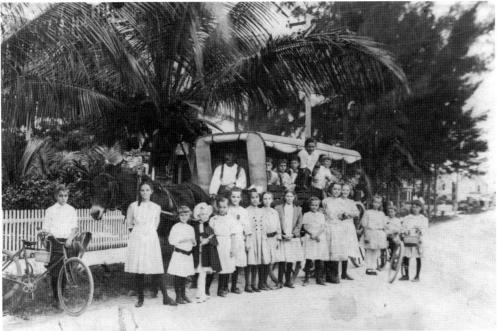

Early School Transportation
Children board the horse-drawn wagon for their trip up Hibiscus Street to the new Central School in 1910. Guy Metcalf promoted the construction of the school, built of concrete and designed by architect William Maughlin. (Courtesy of the State Archives of Florida.)

CHAPTER TWO

The Developers
Sell Paradise

Florida's land schemes, through boom and bust, have been a large part of the colorful business landscape in West Palm Beach. Many unsuspecting Northerners bought land sight unseen and were surprised to discover, as an early buyer noted, that in Florida, one does not buy land by the foot or acre but often by the gallon. Many people made fortunes by purchasing land at low prices through homesteading or buying cheap from those who tired of the hot Florida summers and relentless mosquitoes. Covered by a thick sand pine forest dotted with high sandy hills, the land north of the original townsite saw only small farms. Farmers cleared land south of the townsite on the sandy ridge and planted large tracts of pineapples, which grew well in the Florida climate. Once cheaper Cuban pineapples hit the market and land began to increase in value, developers cleared the former pineapple farms and wooded areas for subdivisions.

Developers subdivided the former farming tracts into 25- or 50-foot lots, and small cottages as well as larger homes quickly sprang up during the 1920s boom era. Developments such as Belair, Central Park, El Cid, Flamingo Park, Grandview Heights, Mango Promenade, Northboro Park, Northwest, Northwood Hills, Old Northwood, Pleasant City, Prospect Park, Vedado-Hillcrest, and West Northwood all emerged as significant neighborhoods between the 1910s and 1950s. After that time, westward expansion came into play with the Villages, the Land of the Presidents, and Roosevelt Heights.

Developers transformed the downtown area from what were formerly residential areas on Datura and Evernia Streets to become part of the commercial downtown districts. West Palm Beach was no longer a small frontier town but an emerging city, built by architects and developers who sold paradise to anyone who would buy.

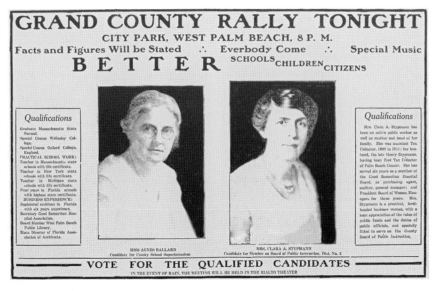

GRAND COUNTY RALLY TONIGHT
CITY PARK, WEST PALM BEACH, 8 P. M.
Facts and Figures Will be Stated ∴ Everbody Come ∴ Special Music

BETTER SCHOOLS CHILDREN CITIZENS

Qualifications

Graduate Massachusetts State Normal.
Special Course Wellesley College.
Special Course Oxford College, England.
PRACTICAL SCHOOL WORK: Teacher in Massachusetts state schools with life certificate.
Teacher in New York state schools with life certificate.
Teacher in Michigan state schools with life certificate.
Four years in Florida schools with highest state certificate.
BUSINESS EXPERIENCE: Registered architect in Florida with six years experience.
Secretary Good Samaritan Hospital Association.
Board Member West Palm Beach Public Library.
State Director of Florida Association of Architects.

Qualifications

Mrs. Clara A. Stypmann has been an active public worker as well as mother and head of her family. She was assistant Tax Collector, 1909 to 1911; her husband, the late Henry Stypmann, having been first Tax Collector of Palm Beach County. She has served six years as a member of the Good Samaritan Hospital Board, as purchasing agent, auditor, general manager; and President Board of Women Managers for three years. Mrs. Stypmann is a practical, levelheaded business woman, with a keen appreciation of the value of public funds and the duties of public officials, and specially fitted to serve on the County Board of Public Instruction.

MISS AGNES BALLARD
Candidate for County School Superintendent

MRS. CLARA A. STYPMANN
Candidate for Member on Board of Public Instruction, Dist. No. 2

— VOTE FOR THE QUALIFIED CANDIDATES —
IN THE EVENT OF RAIN, THE MEETING WILL BE HELD IN THE RIALTO THEATER

Agnes Ballard, Architect, School Superintendent, and Teacher

Agnes Ballard was a woman of many firsts in West Palm Beach and in Florida. Trained as a schoolteacher, she came to the area in 1906 to escape the cold weather she so disliked. She taught in many area schools but moved to Wisconsin to study architecture. Ballard returned to the area and became Florida's first female registered architect in 1915. She opened up her own practice, initially using her home as office and studio. In 1920, she decided not only to exercise her new right to vote but also to run for office. Ballard and colleague Clara A. Stypmann became the first women to hold elected office in Palm Beach County. Voters elected Ballard as superintendent of public instruction, a role in which she served from 1920 to 1924. Ballard led the school district through the boom years of incredible growth. She resumed her architecture practice in 1925 and made good money selling real estate. Ballard toured Europe and came back to find America mired in the Great Depression. She returned to teaching but kept up her architecture practice; one of her home designs is pictured below. She retired at age 80, leaving a pathway of firsts for women in Palm Beach County. (Above, courtesy of the *Palm Beach Post*; below, authors' collection.)

George F. Bensel, Land and Timber Developer

In 1902, the Southern States Land & Timber Company completed one of the largest land transactions in Florida history. The company purchased two million acres of South Florida land from Hamilton Disston's heirs for 25¢ an acre. Disston had once owned over four million acres of Florida land, but his drainage schemes were largely unsuccessful. George F. Bensel joined the company in 1903, and drainage and development of the lands began. Bensel was largely responsible for founding the town of Loxahatchee Groves in 1917, which had demonstration farms for citrus, dairy, and cattle ranching. The Southern States Land & Timber Company occupied much of the new Harvey Building downtown when it was completed in 1926. That year, Bensel was also named president of the Greater Palm Beach Chamber of Commerce. Bensel remained with the firm for many decades, and the company board elected Bensel president in 1943. Bensel purchased all the remaining land in Loxahatchee Groves in 1948 and lived in West Palm Beach until his death in 1961. Bensel and his wife, Ernestine, are pictured here at a local event. (Courtesy of the Historical Society of Palm Beach County.)

E. Llwyd Ecclestone, Developer

Real estate mogul E. Llwyd Ecclestone developed many of Palm Beach County's premier residential and commercial holdings, including PGA National, Old Port Cove, Lost Tree Village, and the Forum office buildings. Since coming to Palm Beach County in 1965, Ecclestone has developed $1.3 billion of assessed property. Ecclestone is a strong community advocate, serving on many boards and supporting causes such as the Kravis Center for the Performing Arts. (Courtesy of the *Palm Beach Post*.)

Irwin H. Levy, Developer

H. Irwin Levy developed a new dimension in Florida living with his resort-style condominium communities. His 1968 Century Village concept ushered in retirement living in West Palm Beach. He transformed 680 acres of ranch and swamp into a year-round golf and tennis haven complete with 18 swimming pools and many shuffleboard courts. Retirees scooped up 8,000 of the inexpensive little condominiums in less than four years. So successful was Levy's plan to make money from the recreation facilities and service fees, additional Century Village communities sprang up in Deerfield Beach, Boca Raton, and Pembroke Pines. (Courtesy of the *Palm Beach Post*.)

Rick Gonzalez, Architect

Architect Rick Gonzalez provides walking history and architectural tours of downtown West Palm Beach. In addition to designing new buildings, Gonzalez, who opened his practice in 1988, has won many American Institute of Architects Palm Beach and Florida Trust for Historic Preservation Awards for his work on historic buildings. Some of the preservation projects Gonzalez's firm has headed are Donald Trump's mansion Mar-A-Lago, the Harriet Himmel Theatre at CityPlace, and the 1916 courthouse. (Courtesy of Rick Gonzalez.)

Otto "Buz" DiVosta, Developer and Builder

One of Palm Beach County's most prolific builders, Buz DiVosta pioneered many building techniques, including the Moduplex poured-concrete mold system that sped construction and saved costs. He also had large sections of homes built on assembly lines and trucked to homesites. DiVosta has built thousands of condominiums, townhouses, and luxury homes throughout Palm Beach County. He sold his firm to the Pulte Group in 1998. (Courtesy of the *Palm Beach Post*.)

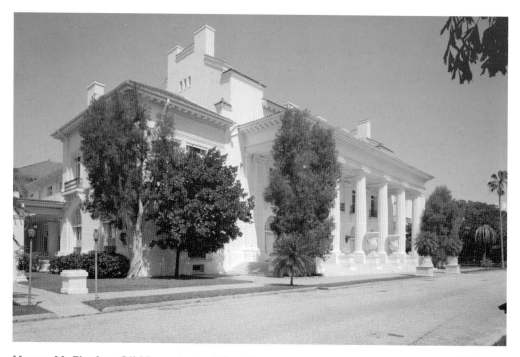

Henry M. Flagler, Oil Magnate and Developer

One of America's wealthiest men, Standard Oil multimillionaire and railroad tycoon Henry Morrison Flagler set his sights upon South Florida in the 1890s, one of the last undeveloped continental frontiers. Flagler's grand hotel system, the Florida East Coast Railway, and his subsidiaries, including the Model Land Company, forever changed the landscape of South Florida and set the stage for a century of land development. Flagler's 1894 Royal Poinciana Hotel in Palm Beach spawned West Palm Beach, service town and home to the many construction workers, railroad employees, servants, and seasonal workers who had background roles in America's playground for the rich and famous. The state of Florida granted thousands of acres to Flagler's companies along the path of his railroad extension, and the companies advertised the fertile fields, robust climate, and amenities to homesteaders. Flagler's dynasty, hotel systems, land schemes, and reputation brought unprecedented growth to West Palm Beach well after his death in 1913. The photograph above shows his Palm Beach palace, Whitehall, built for his third wife, Mary Lily, in 1901. (Right, courtesy of the State Archives of Florida; above, courtesy of the Library of Congress.)

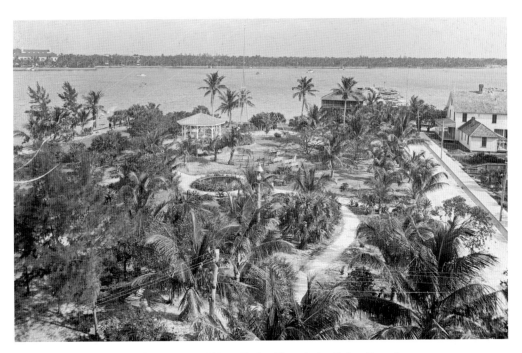

Flagler Park and the View from West Palm Beach to Palm Beach

When Henry Flagler had West Palm Beach platted in 1894, he donated a large park east of Clematis Street, which remains a focal point of recreation, festivals, and strolling. Seen above in 1910, Flagler Park once housed the West Palm Beach Woman's Club and two library buildings, built in 1917 and 1962. These buildings have all been demolished, leaving the large green space seen today. The bottom photograph features Palm Beach and the imposing Royal Poinciana Hotel. It was once the largest wooden structure in the world and hosted many of America's wealthiest families during its short season from December through February. Guests never saw the famed royal poinciana tree in bloom, as its garish red blossoms typically appear in late May. (Both, courtesy of the Library of Congress.)

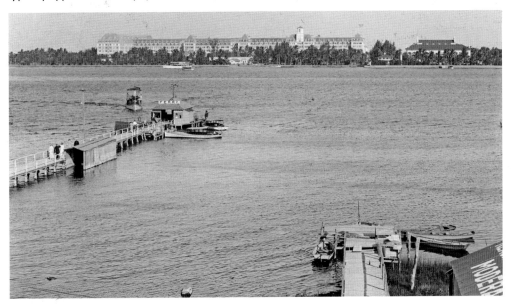

**Henry Stephen Harvey and
L. Phillips Clarke, Architects**
Henry Stephen Harvey (top) and L.
Phillips Clarke (bottom) did more to
define the skyline and style of West
Palm Beach's downtown than any other
architectural firm. Their first building, the
1921 American National Bank Building, is
a three-story Neoclassical design. They
built the 10-story Comeau Building and
the 14-story Harvey Building, which was
West Palm Beach's tallest building for
decades. The Seaboard Coast Line Railroad
Station remains an iconic structure that
has greeted thousands of residents and
tourists since it opened in 1925. Of
their buildings and homes in West Palm
Beach, 10 have been listed in the National
Register of Historic Places. Henry S.
Harvey also served as mayor in the 1920s.
(Both, courtesy of Joan Beach.)

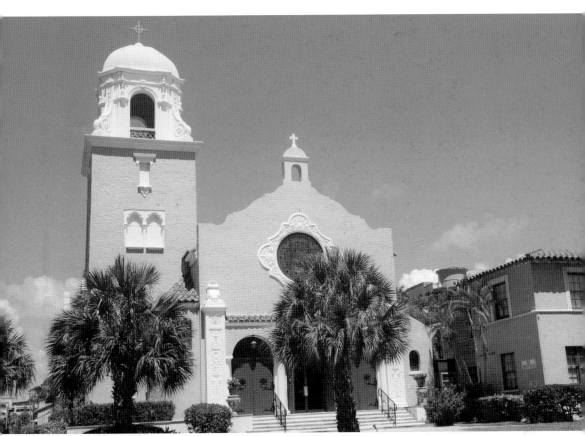

Harvey & Clarke–Designed Buildings

The two structures seen here are excellent examples of Harvey & Clarke designs. Above is the Holy Trinity Episcopal Church, erected in 1924. The lot originally housed the Anthony family home. Clarke made the church chandeliers and chains himself. At left is the 14-story Harvey building (built for developer George Harvey), erected in 1926 and still in use today as an office building in the downtown area. (Both, authors' collection.)

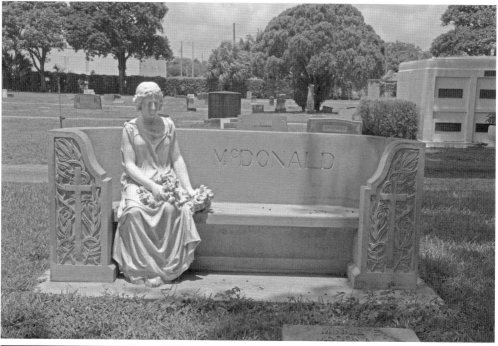

J.B. McDonald, Real Estate Agent and Developer

James Brainard McDonald, a sales representative for Henry M. Flagler's Model Land Company, promoted land sales in West Palm Beach. Known as the "Land Man," McDonald developed the boom-time Grandview Heights development; he also served on the Lake Worth Water Management District board. McDonald's family plot in Woodlawn Cemetery features an unusual statue of a woman resting on a bench. This memorial is one of the most photographed monuments in Woodlawn Cemetery. McDonald resided in Grandview Heights, where the image at left of coconut palms and a mother and her children tells of a carefree time. (Above, authors' collection; left, courtesy of the State Archives of Florida.)

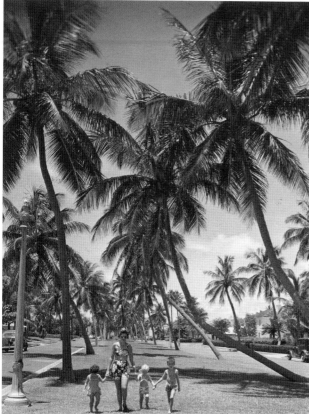

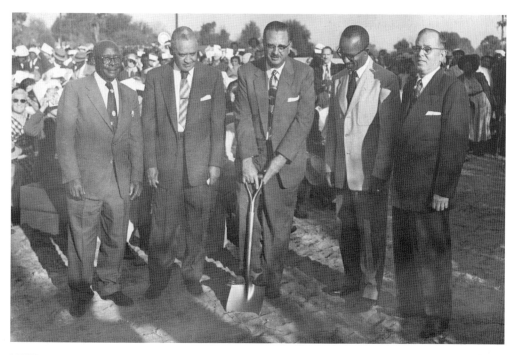

William Manly King, Architect

Sturdy schools that have stood the test of time are hallmarks of William Manly King's designs. Born in Mississippi, King was educated at Georgia Tech. He practiced in West Palm Beach from 1920 until his passing in 1961. His designs include many area schools such as the original Palm Beach Junior College building (listed in the National Register), Palm Beach High School, Southboro Elementary, Northboro Elementary, Palm Beach Junior High School, Boynton High School, Canal Point Elementary School, Jupiter School, and the Pahokee High School (listed in the National Register). He also designed many residences, the Hotel Monterey on Clematis Street, and the West Palm Beach Armory, now the Armory Art Center. King is pictured above at center at a ground-breaking ceremony with unidentified dignitaries. The bottom photograph features his Palm Beach High School building. (Above, courtesy of the State Archives of Florida, below, authors' collection.)

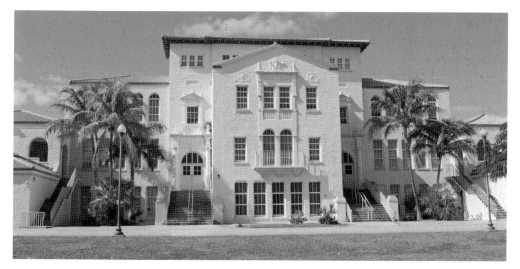

Albert Edward Parker, City Manager

Albert Edward Parker, city manager from 1927 to 1930, immigrated to America in 1886 from England. Parker has the distinction of being one of the first naturalized citizens in Palm Beach County, sworn in on the day the county began—July 1, 1909. Parker, who went by the initials "A.E." or "Bert" managed the Boynton Hotel for 20 years and married Anna Boynton, the daughter of Maj. Nathan S. Boynton, for whom the city of Boynton Beach was named. Above, Parker is behind the man in the dark suit, with Anna on his left. Parker had the first dairy in Boynton, the Bertanna farm, which was a combination of his first name and Anna's. Parker helped found the first public golf course, the original West Palm Beach Country Club, on the site of what is today Palm Beach International Airport. The Town of Golfview's famous entrance gates now grace the entrance to Yesteryear Village, where Parker's name is engraved. Parker went on to dabble in real estate and build a beautiful Mediterranean Revival house on Flagler Drive, seen below. Parker passed away in 1935. He and Anna are interred at Woodlawn Cemetery. (Above, courtesy of Boynton Beach Historical Society; below, authors' collection.)

Lou Perini, Developer
The original land area of West Palm Beach was only a mile wide, with land west of the city limits a vast wetland. The city bought 17,000 acres of the wetlands from Flagler's Model Land Company to build a modern water and sewer system. In 1957, the city sold 5,500 of these acres to developers, including Lou Perini. He set to work with his idea of westward expansion, a plan to completely transform the city. One of the largest planned communities in Florida, Perini's project drained thousands of acres to build houses, condominiums, shopping centers, and golf courses. Palm Beach Lakes Boulevard became the main artery to the developments. Perini sold drained parcels to other developers to build projects such as the Palm Beach Mall. (Courtesy of the *Palm Beach Post*.)

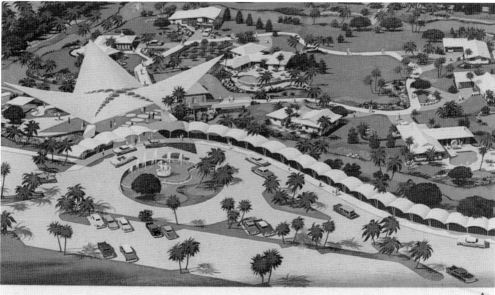

Center of attraction at beautiful Palm Beach Lakes is the spectacular Million Dollar Homes Exhibit.

Westward Expansion
Lou Perini used advertising postcards such as this one to entice homebuyers to the emerging developments in the newly drained land tracts. What was once swampy land used by the Seminoles for hunting and fishing was now prime real estate for new developments and new Florida residents. (Authors' collection.)

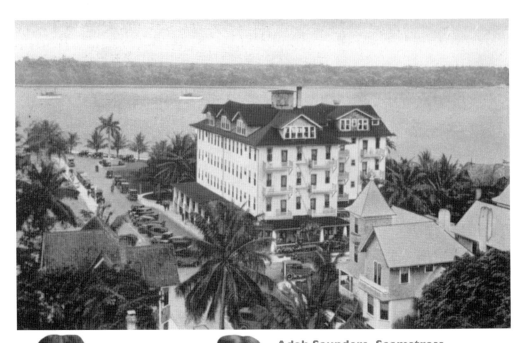

Adah Saunders, Seamstress and Land Investor

Adah Saunders relocated from Titusville to West Palm Beach in the 1890s. She ran a highly successful seamstress business, with the Palm Beach elite as customers. Her son William ran the Hotel Salt Air, one of the beautiful cottage hotels along the waterfront. Saunders owned and operated a unique local attraction called Birdland in the 1920s and 1930s. The family property, with over 900 birds, encompassed the area from Forty-fifth Street to Fifty-fourth Street. Later, Saunders donated a large part of her land for St. Mary's Hospital, now St. Mary's Medical Center. Saunders is pictured with her sons John Weihe (left), a boat captain, and William Weihe (right). (Left, courtesy of Larry Grosser; above, authors' collection.)

CHAPTER THREE

Artists, Entertainers, and Athletes

The recreational and leisure aspects of a city's development add as much interest as its buildings and environment. Early venues such as the Flagler Park Band Shell provided locals a place where music could be made and heard, featuring the West Palm Beach Municipal Band playing the American march music of the day.

West Palm Beach has produced and attracted many people with artistic and athletic talent. Those who arrived in the early years often came for health reasons, hoping to recuperate in the warm sunny winters, living in their cottages along Lake Worth. Writers, sculptors, musicians, and actors were drawn by West Palm Beach and the Palm Beach resorts. The warm spring weather proved to be an ideal climate for baseball players to shake their winter doldrums and tune up for a long summer playing America's pastime on the diamond. Baseball teams such as the Philadelphia Athletics, the Atlanta Braves, the Montreal Expos, and the St. Louis Cardinals have held spring training in the area.

Artists often took up residence in West Palm Beach, practicing their talents in the inspiring land of eternal sunshine. Many who were born in South Florida and made good on the national scene returned to live in the Palm Beaches, and those who came to train moved to the area. Area high schools have produced first-class athletes in baseball, football, and basketball.

Music and entertainment have returned to the lakefront with the Meyer Amphitheatre and its 10,000-square-foot band shell. The venue serves as the main stage for SunFest, the city's annual music and arts event held each May.

No community is complete without culture, athletics, and artistic expression, and the people profiled in this chapter fit the bill.

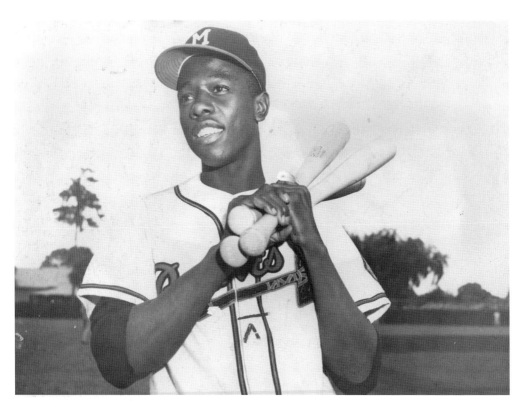

Hank Aaron, Baseball Player
Hammerin' Hank Aaron has been on the West Palm Beach scene for more than 50 years. In 1963, the Milwaukee Braves moved their spring training facility from Bradenton, Florida, to West Palm Beach. The Braves trained at the now-demolished municipal stadium near Palm Beach Lakes Boulevard. When Aaron reigned as king with 715 home runs, the city changed the address of the stadium to 715 Hank Aaron Drive. A member of the Palm Beach County Sports Hall of Fame, Aaron has a home in West Palm Beach and still works with community leaders on projects such as revitalizing Coleman Park, where many early African American baseball legends such as Jackie Robinson and Satchel Paige played the game. (Courtesy of the *Palm Beach Post*.)

Gary Carter, Baseball Player and Coach
Baseball Hall of Fame catcher Gary Carter, beloved by fans and known as the "Kid," trained in West Palm Beach with the Montreal Expos. He loved the area, made it his home, and was inducted into the Palm Beach County Sports Hall of Fame in 1991. His last baseball stint was coaching the Palm Beach Atlantic University baseball team. Carter passed away in 2012 after a battle with cancer. (Courtesy of the *Palm Beach Post*.)

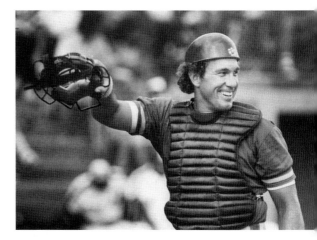

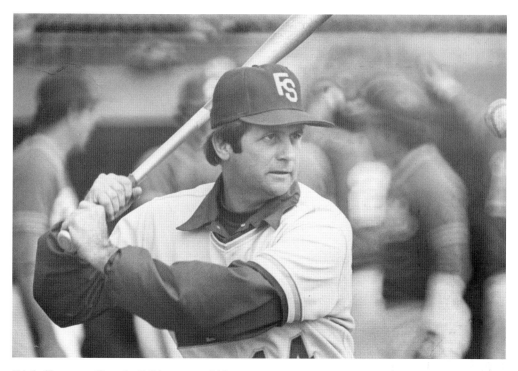

Dick Howser, Baseball Player and Manager
A baseball playing and coaching phenom, Dick Howser starred on the Palm Beach High School baseball team in the 1950s. He went on to play at Florida State University, where the baseball stadium bears his name. He played with the Kansas City Athletics, the Cleveland Indians, and the New York Yankees. His managerial career saw its highlight with the 1985 Kansas City Royals as he guided the team to its only World Series win. Howser was inducted into the Palm Beach County Sports Hall of Fame in 1978. His life ended early when cancer claimed him at age 51. (Courtesy of the *Palm Beach Post*.)

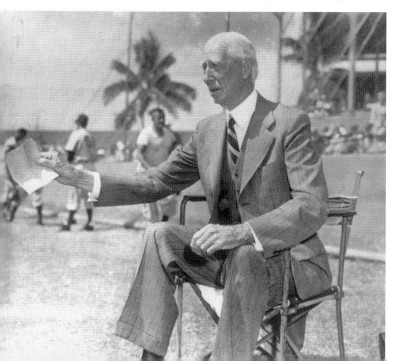

Connie Mack, Baseball Manager
The legendary manager of the Philadelphia Athletics, whose given name was Cornelius McGillicudy, managed the Athletics from 1901 to 1950. The team held spring training in West Palm Beach from 1945 to 1962 at Connie Mack Field, now the site of the Kravis Center parking garage. (Courtesy of the *Palm Beach Post*.)

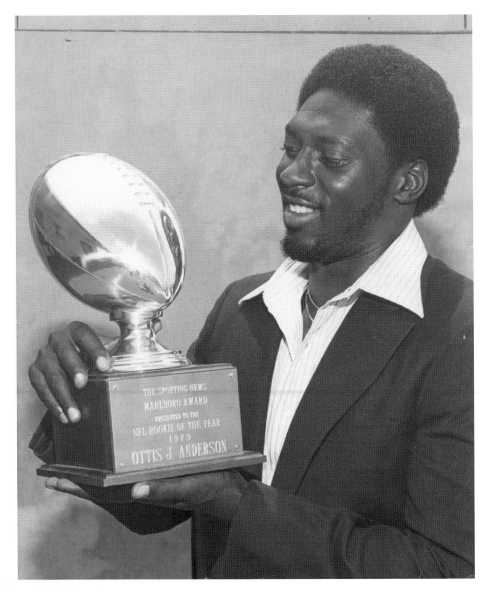

THE SPORTING NEWS
MARLBORO AWARD
PRESENTED TO THE
NFL ROOKIE OF THE YEAR
1979
OTTIS J. ANDERSON

Ottis Anderson, Football Player and Motivational Speaker
Former NFL running back Ottis Jerome Anderson grew up in West Palm Beach and played football and ran track for the Forest Hill High School Falcons. The powerful running back credits his passion for football to his older brother Marvin "Smoke" Anderson, a football player at the then-segregated Roosevelt High School. Known as "OJ," Anderson played for the University of Miami Hurricanes from 1975 to 1979. The St. Louis Cardinals chose Anderson in the first round of the 1979 draft. He was named NFL Rookie of the Year as well as Most Valuable Player in 1979, earning All-Pro status in 1979–1981. He was recognized locally with his 1982 induction into the Palm Beach County Sports Hall of Fame. In 1986, the New York Giants traded for Anderson, who scored the final touchdown for the Giants' Super Bowl XXI victory. In 1990, Anderson's moves during Super Bowl XXV merited the Super Bowl MVP title. After 14 years in the NFL, Anderson retired in 1992 and serves as a motivational speaker and broadcaster. The Ottis J. Anderson scholarship assists needy students from West Palm Beach in reaching their goal of a college education. (Courtesy of the *Palm Beach Post*.)

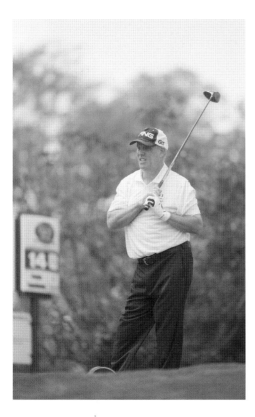

Ken Green, Golfer

Victory, heartbreak, and comeback are all part of Ken Green's story. He attended Palm Beach Junior College and the University of Florida on golf scholarships and turned professional in 1979. He won five PGA events. In 2009, Green lost his lower right leg in an accident that claimed the lives of his brother, girlfriend, and dog. In spite of the tragedy, Green returned to competitive golf on the Champions Tour. His accomplishments were recognized with his 2011 induction into the Palm Beach County Sports Hall of Fame. (Courtesy of Keith Allison under Creative Commons, CC by SA 2.0.)

Mark Calcavecchia, Golfer

Winner of 13 PGA tour events, Mark Calcavecchia came to West Palm Beach as a teenager. He was high school golf champion in 1977 and then attended the University of Florida. He advanced to the professional tour in 1981, with his biggest win coming at the British Open in 1989. He currently competes on the Champions Tour, where he has chalked up two wins. In 2009, he was inducted in the Palm Beach County Sports Hall of Fame. (Courtesy of the *Palm Beach Post*.)

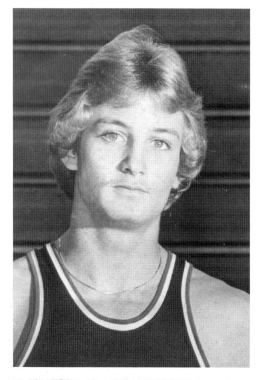

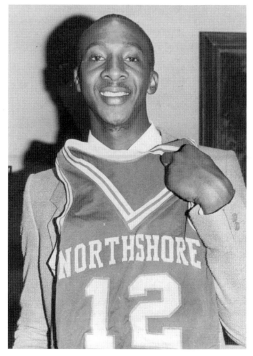

Robby Thompson, Baseball Player and Coach

A star for the Forest Hill Falcons, Robby Thompson earned his reputation through his gritty defense at second base, hitting, and base speed. The San Francisco Giants drafted Thompson in the first round, and he won the Sporting News Rookie of the Year award in 1986. Fans named him to the 1988 and 1993 National League All-Star teams; Thompson also won the Golden Glove award and the Silver Slugger award in 1993. He was inducted into the Palm Beach County Sports Hall of Fame in 1994. He played his last major-league game in 1996 when injuries cut short his career at age 34. Thompson has coached at the major-league level with the Cleveland Indians and the Seattle Mariners. (Courtesy of the *Palm Beach Post*.)

Derek Harper, Basketball Player

A West Palm Beach native, point guard Derek Harper graduated from North Shore High School and played college basketball at the University of Illinois; in 2004, he was named to the university's All Century Team. Harper was a first-round draft pick in the 1983 NBA draft and played 10 seasons with the Dallas Mavericks. His play was recognized with his 1991 induction into the Palm Beach County Sports Hall of Fame. He played for several other NBA teams before wrapping up his 16-year career with the Los Angeles Lakers in 1999. (Courtesy of the *Palm Beach Post*.)

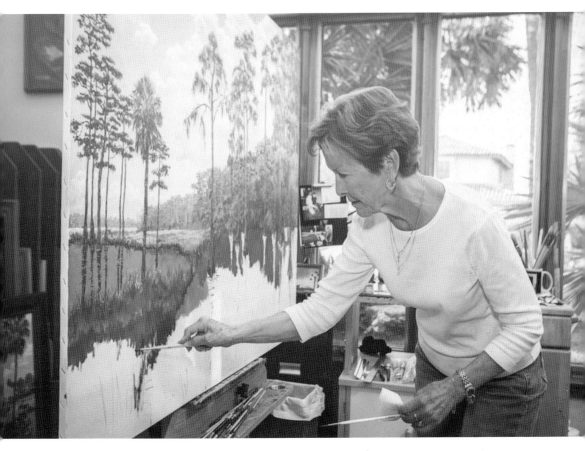

Jackie Brice, Artist and Muralist

Native Floridian and landscape artist Jacqueline "Jackie" Brice moved to West Palm Beach in 1984 with her husband, Herman Brice, Palm Beach County fire rescue chief. Jackie studied for 11 years with her mentor and friend, A.E. Backus, teacher of the well-known Florida Highwaymen landscape artists. She has exhibited her artwork in the Governmental Center, Ann Norton Sculpture Gardens, Governors Club, and Northwood University. Her works are in the permanent collection of the White House and the Florida House of Representatives. In 2002, she designed a Christmas ornament for the White House. Her oil painting of the 1916 Palm Beach County Courthouse hangs in the Richard and Pat Johnson History Museum in the restored historic courthouse. In 2012, Jackie Brice was inducted into the Florida Artists Hall of Fame. She is very active in her community, teaching, volunteering, and helping in many ways to preserve this great state. She provides scholarships to students who need help with college and donates 10 percent of her earnings to charities and people in need. (Courtesy of Jackie Brice.)

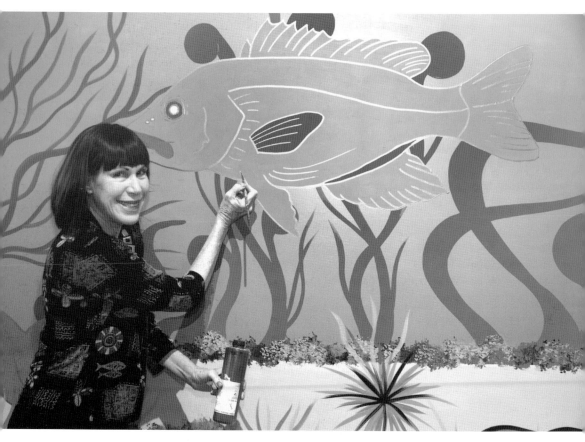

Sharon Koskoff, Artist

For over 30 years, muralist Sharon Koskoff has left her imprint upon walls, buildings, and benches across West Palm Beach and Palm Beach County. The vibrant Koskoff founded the Art Deco Society of the Palm Beaches in 1987 and was the recipient of the 2014 Muse Award from the Cultural Council of Palm Beach County as arts educator of the year. Koskoff's murals decorate many schools and buildings throughout West Palm Beach and the Palm Beaches, including Good Samaritan and St. Mary's Hospitals, Northmore Elementary School, Clematis Street benches, Armory Art Center, Norton Museum of Art, the South Florida Science Museum (pictured), and Palm Beach International Airport. Koskoff gives tours of Art Deco building districts and authored the book *Art Deco in Palm Beach County* in 2007. (Courtesy of Sharon Koskoff.)

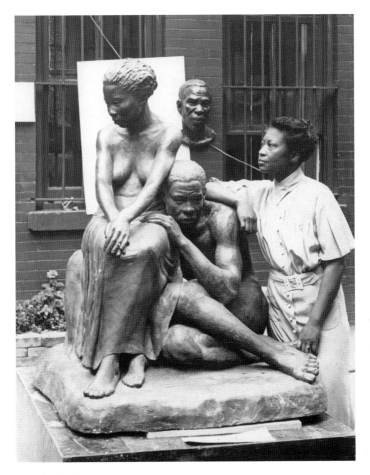

Augusta Savage, Sculptor

Born in Green Cove Springs, Florida, in 1892, Augusta Christine Fells came from a poor family with 13 children. With no money for toys, her creative spirit found an outlet in the clay pit near her backyard. She created animal sculptures; her father, a minister, did not approve of her creating "idolatry" of God's creatures. The family moved to West Palm Beach in 1907. While on a school trip, she rode past a pottery business. She yelled for the wagon to stop. The potter was so impressed with her excitement that he gave her several buckets of clay. After seeing Savage's sculpture of the Virgin Mary, her father realized her great talent. George Graham Currie also recognized her talent. Currie was serving as the secretary of the Palm Beach County Fair in 1916, and over objections from some fair officials, allowed Savage to display and sell her works. Not only did she sell $175 in sculptures, she won a $25 prize at the fair. Currie helped Savage gain entrance to the Cooper Union art school in New York. In 1924, she received her first commission, a sculpture of W.E.B. DuBois for a Harlem library. In 1925, she won a scholarship to the Royal Academy of Fine Arts in Rome but was unable to attend because it only covered tuition. Her dream of studying abroad was finally realized in 1929 when the Julius Rosenwald Foundation funded her study at a leading Paris art school. In 1934, she opened her own art school in Harlem. Savage received a commission from the 1939 New York World's Fair and created a sculpture titled *Lift Every Voice and Sing*. The large sculpture was cast in plaster, as she could not afford bronze. The plaster cast of the sculpture was destroyed after the fair, and only small models remain. Savage abandoned her art career and moved to upstate New York. She rarely spoke of her career; occasionally, she would teach an art class. As her health faltered, she moved to her daughter's home in New Jersey. She died on March 26, 1962. (Courtesy of the Library of Congress.)

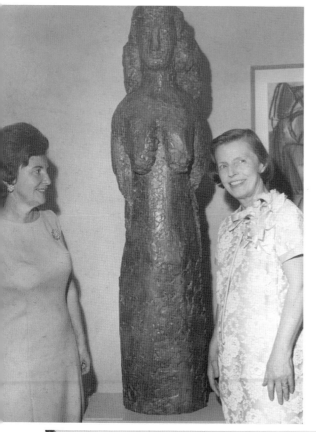

Ann Norton, Sculptor

Sculptor Ann Vaughan Weaver Norton, second wife of Ralph Hubbard Norton, created monumental works of art in her West Palm Beach studio on picturesque Flagler Drive. At left, Norton is seen on the right next to one of her sculptures. The Nortons met in 1942 when Ann taught sculpting classes at the Norton Gallery and School of Art. They married after Norton's first wife passed away. Ralph Norton died five years after their marriage; he left Ann Norton with the means to use her artistic talent to leave a lasting legacy. She established the Ann Norton Sculpture Gardens Inc. in 1977. The 1.7-acre property features the Norton house, listed in the National Register of Historic Places in 1990, and more than 100 sculptures amid over 300 species of tropical palms and rare plants. The bottom photograph shows one of her brick-based sculptures, with the Norton home in the background. (Left, courtesy of the *Palm Beach Post*; below, authors' collection.)

Ralph H. Norton, Philanthropist and Art Collector

A Chicago industrialist who made his fortune in the steel business, Ralph Hubbard Norton retired to West Palm Beach in 1940 and searched for a suitable facility to house his extensive art collection. Pioneer Park was the site chosen to build the Norton Gallery and School of Art, known today as the Norton Museum of Art. The museum is seen below from its Olive Avenue side. For his support of the arts, Norton was inducted into the Florida Artists Hall of Fame. (Left, courtesy of State Archives of Florida; below, authors' collection.)

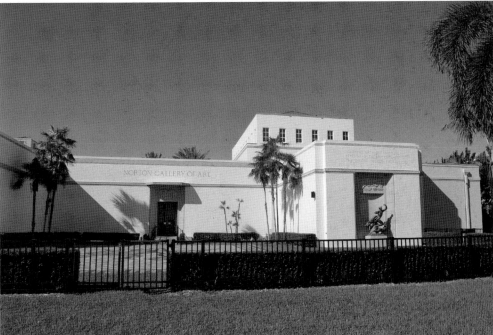

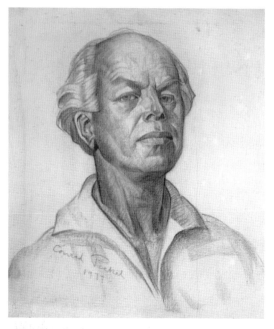

Conrad Pickel, Stained-Glass Artist
Distinguished German-born stained-glass artist and visionary Conrad Pickel has designed thousands of windows for more than 800 churches throughout the United States. A lifelong artist, painter, sculptor, and teacher, Pickel's patented Decralite blocks and leaded and faceted stained-glass windows adorn many church buildings in West Palm Beach, including the largest stained-glass window in Palm Beach County, located in the former Union Congregational Church on Georgia Avenue, just south of Belvedere, now the Iglesia Adventista Seventh-day Adventist Church. According to the *Guinness Book of World Records*, Pickel's creation for the mausoleum in Resurrection Cemetery near Chicago is the largest stained-glass window in the world. (Courtesy of Conrad Pickel Studios.)

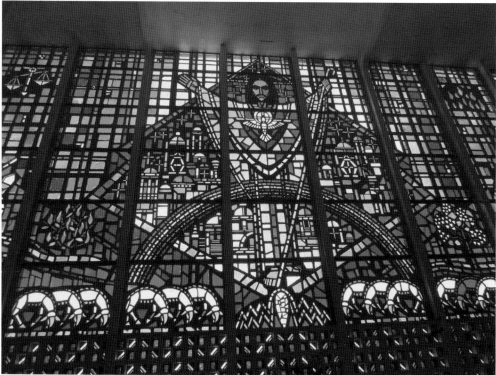

Palm Beach County's Largest Stained Glass Window
Conrad Pickel's masterpiece at the Iglesia Adventista is 75 feet long and 24 feet high and depicts scenes from the Old and New Testaments. Over 10,000 pieces of one-inch-thick faceted glass were used to create the window. (Authors' collection.)

Mizner Retail Shop
Addison Mizner sold his architectural wares from several retail locations, such as this shop in Palm Beach off of Worth Avenue in Via Parigi. (Courtesy of the State Archives of Florida.)

Addison Mizner, Architect and Developer
Mizner is an oft-heard name locally, synonymous with Spanish architecture in Florida. Addison Cairns Mizner, born and buried in California, left his imprint upon much of Palm Beach County from his 1918 arrival and well past his death in 1933. Up to that time, West Palm Beach's architecture was largely based on wooden cottages in the Frame Vernacular style. To create his popular Mediterranean Revival and Spanish Colonial Revival interpretations, Mizner established workshops around the county. Mizner Industries Inc. on Bunker Road in West Palm Beach manufactured clay roof tiles, cast stone, forged iron, tile, and other materials and furniture that mimicked old-world antiques. These creations are still sought after by architectural, construction, and restoration firms. (Courtesy of the *Palm Beach Post*.)

William "Washboard Bill" Cooke, Entertainer
Known simply as Washboard Bill, William Cooke, a child of the Great Depression who spent 10 years as a hobo, entertained people with his unusual style of music. The talented percussion musician and storyteller played two washboards with attached cymbals and cowbells rather than traditional drums. He formed a band and earned the moniker Washboard Bill. Cooke worked in Harlem clubs in the summer and spent winters in Florida. Between 1947 and 1963, he and his bandmates performed at the West Palm Beach railway station and in private homes and clubs. In the 1970s, Cooke moved to West Palm Beach and continued to play his music, sometimes on street corners and in city parks, until his death in 2003. For his musical and historical contributions, Cooke received the Florida Folk Heritage Award in 1992. (Courtesy of the *Palm Beach Post*.)

Chris Robinson, Actor
Daytime drama star Chris Robinson, born in West Palm Beach, played Dr. Rick Webber on *General Hospital* from 1986 until 2002. Robinson also starred in the 1960s television series *Twelve O'Clock High* and guest-starred on many other television shows. In the late 1960s, Robinson lived in Boynton Beach and Hypoluxo, where he ran a sailboat business and a film-production company. (Courtesy of the *Palm Beach Post*.)

Larry the Cable Guy, Entertainer
One of America's most well known comedic superstars previously entertained audiences by hosting open-mic night at West Palm Beach's Comedy Corner next to the Carefree Theatre. Daniel Lawrence Whitney, or Danny, as he was known in high school at King's Academy and Berean Christian School, used his musical talent, acting ability, and comedic genius to launch a career as the character "Larry the Cable Guy." Today, Whitney is a multiplatinum recording artist, Grammy nominee, Billboard award winner, and one of the top comedians in the United States. The Git-R-Done Foundation, named after Larry's signature catchphrase, has donated more than $7 million to charities. (Courtesy of MRH Entertainment.)

George Hamilton, Actor
Film, stage, and television actor George Stevens Hamilton IV graduated from Palm Beach High School in 1957, where he excelled in drama and won the award for best student actor. Hamilton, who went on to appear in more than 80 movies and television episodes, was awarded a star on the Hollywood Walk of Fame in 2009. The popular actor, sometimes referred to as the "Tan One" for his perpetual golden tan and good looks, continues to support and live in his hometown. Hamilton narrated the seven-minute introductory film at the Richard & Pat Johnson History Museum. (Courtesy of Angela George under Creative Commons, CC by SA3.0.)

Cassadee Pope, Musician
Pop star turned country singer and songwriter Cassadee Blake Pope skyrocketed to fame after winning the third season of NBC's hit show *The Voice*. The West Palm Beach native's musical talents blossomed while singing with the award-winning St. Ann School Jazz Band and the Wellington High School Chorus. After graduation from Wellington High in 2008, Pope cofounded the bands Blake and Hey Monday with friend Mike Gentile. Pope's success rests not only in her musical talent but in her tender voice, sweet heart, and compassion resonating with a growing international audience of all ages. (Courtesy of Kristin George.)

Monte Markham, Actor

Monte Markham, whose television career spans more than 50 years, graduated in 1953 from Palm Beach High School, serving as class president. He enrolled at Palm Beach Junior College, where Prof. Watson B. Duncan III inspired him to begin his acting career. Markham has performed as a character actor in many series and narrated feature films and documentaries, including a recent history documentary film produced by the Historical Society of Palm Beach County. (Courtesy of Palm Beach State College.)

Dickey Betts, Musician

A founding member of the Allman Brothers Band, musician and songwriter Dickey Betts was born in 1943 as Forrest Richard Betts in West Palm Beach. As a child, he played ukulele, banjo, and guitar, and as a teenager he joined other musicians on the Florida band circuit. Betts shared lead-guitar duties with Duane Allman in 1969. Betts wrote many songs for the Allman Brothers over his 30-plus-year stint, including "Jessica" (after his daughter) and "Ramblin' Man." In 1995, Betts was inducted into the Rock and Roll Hall of Fame. Today the popular guitarist lives in Sarasota and tours with his own band, Dickey Betts & Great Southern. (Courtesy of Todd Gay.)

George McCrae, Musician

Soul music superstar and disco pioneer George Warren McCrae Jr. rocked his way to the top of the billboard charts with his 1974 release "Rock Your Baby," which sold more than 11 million copies worldwide, hitting the top of the charts in 13 countries. The West Palm Beach native sang in the choir at Payne Chapel AME Church, performed as a member of the Stepbrothers at Palmview Elementary, and rhythm and blues group the Jivin' Jets at Roosevelt High School before jetting to stardom with his hit dance songs. (Courtesy of Fritz van Duinen.)

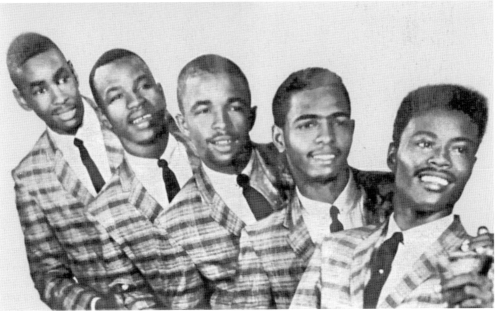

The Jivin' Jets
George McCrae is pictured here with the other members of the Jivin' Jets, his high school vocal group. (Courtesy of the McCrae family.)

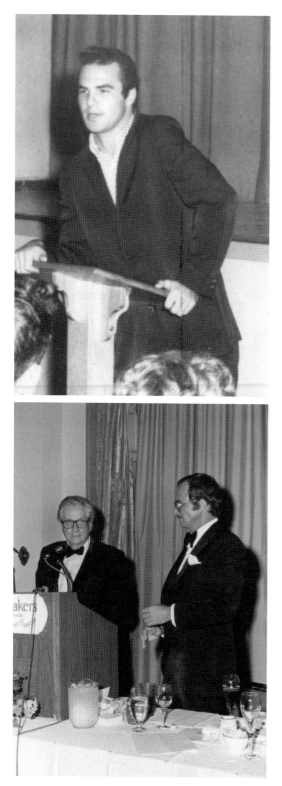

Burt Reynolds, Actor

Burton Leon Reynolds's legendary Hollywood career had humble beginnings on a stage at Palm Beach Junior College. Reynolds enrolled at Florida State University on a football scholarship after graduating from Palm Beach High School in 1954. After an injury ended his professional football hopes, Reynolds returned to West Palm Beach and enrolled at Palm Beach Junior College. Legendary professor Watson B. Duncan III pushed Reynolds into the lead role in a school production. That first performance set the stage for the long career that followed. Reynolds credits Duncan for his career and featured Duncan in cameo roles in several of his movies and television series. Reynolds and Duncan are seen in the bottom photograph at a dinner given in Duncan's honor. Reynolds has won many Golden Globe, Emmy, and People's Choice Awards. (Both, courtesy of Palm Beach State College.)

CHAPTER FOUR

Business Leaders, Newsmakers, and Entrepreneurs

Doing business in paradise may seem like an easy way to make a living, but the tourist season's ups and downs present challenges to successful business ventures. The downtown West Palm Beach area has been the center of banking, commerce, and government for more than a century. In the 1970s and 1980s, much of downtown West Palm Beach was desolate because of the explosion of suburbia with its malls and shopping centers. A renaissance started in the 1990s with major projects such as CityPlace, the new city hall, and the new Mandel Public Library, which revitalized the area. Clematis Street has been the phoenix that rose from the ashes; today it thrives as a nighttime restaurant and entertainment venue.

Many of the business leaders profiled in this chapter survived hurricanes, economic troubles, and population shifts to thrive and serve the community where their business started. The scope of business has always been reflective of the city's industries. Businesses based in tourism, agriculture, retail, and service all serve as important elements of a community. Tourism was always seasonal, and West Palm Beach has worked very hard to become the year-round tourist mecca of today.

Someone also has to tell the story of the community and business, and the area has a long and storied history of news reporting. South Florida's first newspaper, the *Tropical Sun*, moved from Juno to West Palm Beach in 1895, so the tiny town had two newspapers. In the 1950s, television appeared on the scene to provide viewers with local news. The familiar faces of local media serve as calming factors at times of crisis, like when danger from hurricanes is imminent.

Whether retail or wholesale, car dealer or ice cream salesman, these unique personalities and stories illustrate the success of the small business people who act as West Palm Beach's backbone, providing jobs, income, and prosperity to the community.

M. Pope "Ham" Anthony Sr., Department Store Owner
A leader of the Anthony's clothing store dynasty for many decades, Ham Anthony also served his country and community. He served in the US Army in the South Pacific theater in World War II before returning to West Palm Beach to help run the family business. Anthony served as West Palm Beach mayor in the early 1970s, and he founded the Gulfstream Goodwill Industries chapter in 1966 to help the less fortunate. (Courtesy of the *Palm Beach Post*.)

Bill Brooks, Television Station Manager
Each year for the past 30 years, WPTV News Channel 5 conducts a six-week community food drive to feed the hungry and homeless in Palm Beach County. William Joseph Brooks, a former Catholic priest and the general manager for WPTV, founded the Food for Families campaign in 1984. Brooks joined the television station in 1975 as the public service director. The broadcaster and community leader stepped in as WPTV's fourth general manager in 1981 and is credited with propelling the station to one of the most successful NBC affiliates in the country. He served as vice president of Scripps Howard Broadcasting from 1986 until his retirement from the station in 1998. (Courtesy of the Historical Society of Palm Beach County.)

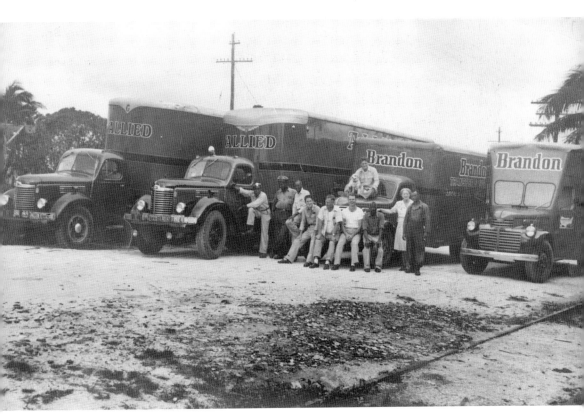

Mary L. Brandon, Moving Company Founder

Entrepreneur Mary L. Brandon founded Brandon Transfer & Storage Company in 1919, the first moving company in West Palm Beach, one year before women earned the right to vote. A staunch pioneer businesswoman, the widowed Brandon ran for supervisor of registration (now called supervisor of elections) for Palm Beach County in 1932. Though Brandon lost to incumbent J.L. Grier, who held the office from 1909 to 1945, she is credited as the first woman to run for this office. Active in the state Democratic Party, the West Palm Beach Chamber of Commerce, and chair of the city's recreation commission, Mary Brandon Park in the Parker Ridge neighborhood was named in Brandon's honor. Brandon's nephew Herbert Lewis assumed the leadership of Brandon Transfer & Storage Company in 1951; today Lewis's children Steve Lewis and Susan Miller run the nearly century-old moving company. (Courtesy of Susan Miller.)

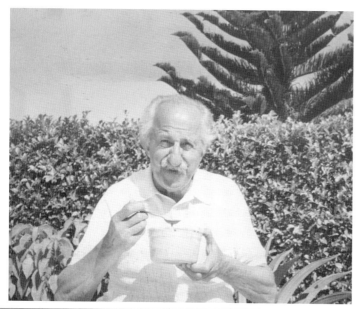

Tom Carvel, Ice Cream Corporation Owner
Arriving from Greece at age four, Tom Carvel made his millions in the soft-serve ice cream business. He retired to West Palm Beach but continued to market Carvel products on television in the 1970s with his signature gravelly voice. (Courtesy of the *Palm Beach Post*.)

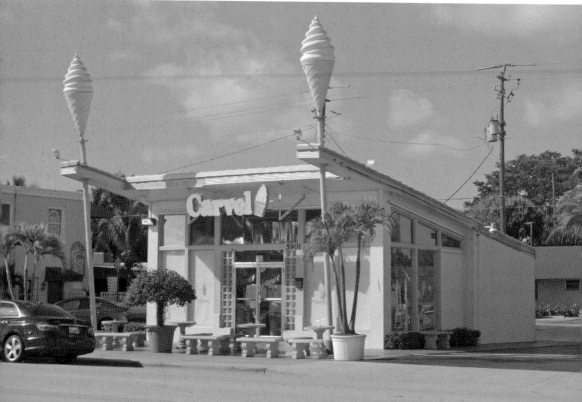

Carvel Ice Cream Store, Dixie Highway
The Carvel Ice Cream Store at 5901 South Dixie Highway is one of the most iconic Carvel stores in America, serving customers since 1958. (Authors' collection.)

John James Cater Jr.,
Furniture Store Owner

John J. Cater expanded the original furniture store started by his father in 1925 to eight stores in three counties. Cater graduated from Palm Beach High School, Palm Beach Junior College, and Stetson University. He began his leadership role in the family business in 1949 and ran the company until he sold it in 2002. He was a devout Christian and active in First Baptist Church activities. (Courtesy of the *Palm Beach Post*.)

Charles E. Merrill, Stock Broker

Founder of one of the most well known brokerage houses in financial history, Charles E. Merrill had one of his first jobs in West Palm Beach, where his father, Dr. Charles M. Merrill, practiced medicine for several years. After attending Amherst College, Merrill Jr. came to West Palm Beach and ran the *Tropical Sun* newspaper in 1906. He stated that running the paper was "the best training I ever had . . . I learned human nature." By 1914, Merrill Jr. founded his brokerage firm with business partner Edmund Lynch. Father and son are interred at West Palm Beach's Woodlawn Cemetery. (Courtesy of the Library of Congress.)

Alf R. Nielsen, Dairy Owner

A dairyman from Michigan, Alfred R. Nielsen's famous logo was seen all over town on delivery trucks, buildings, and signs. Nielsen started the Palm Beach Creamery Company in 1921 in Loxahatchee Groves and then launched the Alfar Creamery Company in 1930 with his dairy plant on Flamingo Drive, which still operates as the McArthur Dairy. Nielsen processed milk purchased from dairies in Jupiter, Boynton, and Lake Park, and each morning he delivered milk packed in ice from his fleet of little white trucks. (Courtesy of Palm Beach State College.)

Carl Kettler Jr., Theater Owner

Moving pictures were all the rage at the turn of the 20th century and found their way to West Palm Beach. Carl Kettler Jr. opened his first theater in 1911, an open-air venue. He later had the Bijou in the Jefferson Building on Clematis Street. Kettler's father, Carl Kettler Sr., was actor Joseph Jefferson's personal aide, and through that relationship, the younger Kettler developed his fascination with show business. In 1924, at the southeast corner of Clematis and Narcissus Streets, he built the ornate Kettler Theatre with 1,400 seats, electric fans, and elaborate lighting. He sold the theater in the early 1930s, and it became the Palms Theatre before its 1965 demolition. (Courtesy of the Historical Society of Palm Beach County.)

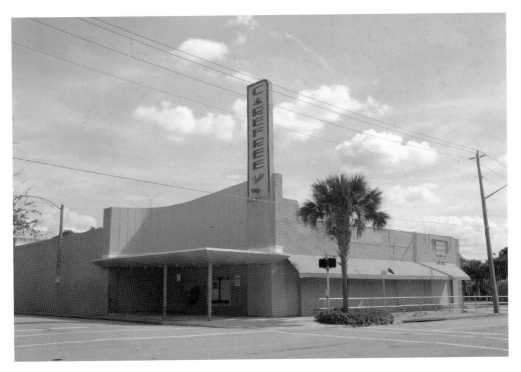

Elias Chalhub, Theater Owner

Syrian-born entrepreneur Elias Chalhub bought a soda fountain and billiard room on South Dixie Highway in 1939 and over the years expanded it into the Carefree Bowling Alley, Café, and Theater. The entertainment center, with its large 75-foot lobby, hosted film premieres and attracted residents and visitors from Palm Beach County and beyond. Chalhub sold his Carefree Center to Fantasma Productions in 1985, and the Comedy Corner offered live concerts, stand-up comedians, and lively stage shows until the establishment closed in 2005 after extensive damage from Hurricane Wilma. (Authors' collection.)

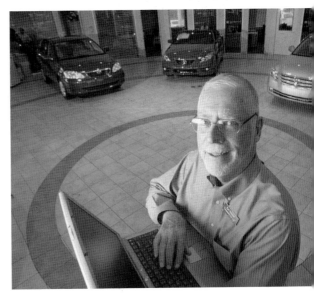

Earl Stewart, Automobile Dealership Owner

Known for his famous red phone accessibility and "no dealer fees" mantra, automobile dealer Earl Stewart has sold cars in the West Palm Beach area since 1968, once owning six dealerships. A native Floridian, Stewart owns a Toyota dealership in North Palm Beach and has a weekly radio show and newspaper column in which he advocates for the consumer. In 2012, Stewart published *Confessions of a Recovering Car Dealer*, with proceeds from its sales going to charity. In recent years, Stewart has partnered with Big Dog Rescue Ranch, paying the adoption fees for anyone adopting the Dog of the Month. (Courtesy of Earl Stewart.)

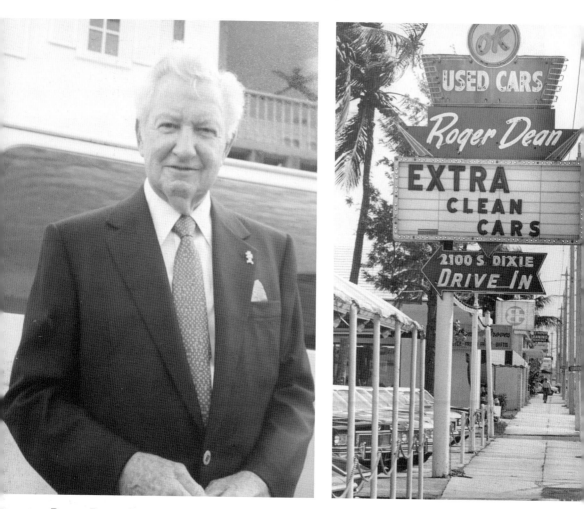

Roger Dean, Automobile Dealership Owner

Automobile tycoon Roger Houston Dean started his career as a dealer with the Ford Motor Company in 1947 and switched to General Motors in 1955. He opened his West Palm Beach dealership, Roger Dean Chevrolet, in the 1960s. Dean was among the first megadealers in the United States and achieved success with his goal to create customers for life by selling cars at fair prices and providing the best customer service possible. In 1996, Dean's daughters paid $1 million to name the new baseball stadium after him. The Florida Marlins and the St. Louis Cardinals train at Roger Dean Stadium, as do the Jupiter Hammerheads and the Palm Beach Cardinals. (Left, courtesy of the Roger Dean family, right, courtesy of the *Palm Beach Post*.)

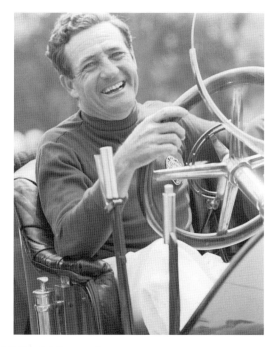

Briggs S. Cunningham, Entrepreneur and Sportsman

Few locals remember that West Palm Beach was once home to an automobile manufacturer. Briggs Swift Cunningham II manufactured high-end sports cars from his plant on Elizabeth Road from 1951 to 1955. Cunningham's passion was cars that went fast, so he took the best high-powered American engine of the time, the Chrysler Hemi V8, and married it to an Italian-designed coach and chassis. The result was the C3, of which Cunningham only made 25 cars. All 25 are still in existence, and each car is valued in the six figures. Cunningham was also an avid yachtsman, and some of his rigging innovations are still in use today, one known as the Cunningham. He won the 1958 America's Cup, sailing the winning yacht *Columbia*. (Courtesy of Ozzie Lyons.)

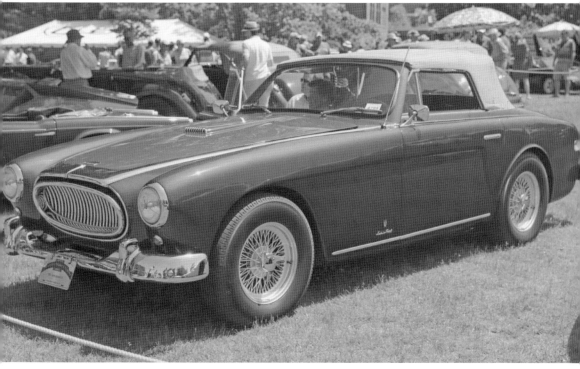

1953 Cunningham C3 Cabriolet

An aluminum body two-seat convertible, this C3 is one of only five convertibles built by Briggs S. Cunningham. It sold for $14,000 new and today is worth considerably more. (Courtesy of Vetatur Fumare under Creative Commons, CC by SA 3.0.)

Alex Dreyfoos, Television Station Owner

Business leader and philanthropist Alexander W. Dreyfoos owns the Dreyfoos Group. His firm owned a controlling interest in television station WPEC TV-12 from 1973 to 1996 and operated the Sailfish Marina from 1977 to 2004. Dreyfoos facilitated formation of the Palm Beach County Cultural Council and led the effort to build the Kravis Center for the Performing Arts. Dreyfoos donated $1 million to Palm Beach County Schools for an arts magnet school. The school district named the school the Alexander W. Dreyfoos School of the Arts. The school occupies the campus of the town's first high school, Palm Beach High School, later called Twin Lakes High School. Famed architect William Manly King designed the high school building. (Courtesy the *Palm Beach Post*.)

Alfonso Fanjul Sr., Sugar Production

Much of the sweet swaying sugarcane grown in western Palm Beach County can be attributed to Cuban immigrant Alfonso Fanjul, whose family began farming sugarcane in Cuba during the 1850s. After losing their land in the 1959 Cuban Revolution, Fanjul bought 4,000 acres of land and barged sugar mills from Louisiana to begin his Florida operations. Florida Crystals now calls downtown West Palm Beach home, and the family's philanthropic activities have benefited many county residents. (Courtesy of the *Palm Beach Post*.)

George Greenberg, Linens Store Owner
Known as the "Mayor of Clematis Street," George Greenberg, owner of Pioneer Linens, also founded the West Palm Beach Downtown Development Authority. His designer linens store, begun by his father, Max Greenberg, opened in 1913 and has graced Clematis Street since 1930. Greenberg, who kept active in community events and in his store's operations until his passing, was known for his excellent community rapport and providing service as fine as his linens. (Courtesy of the *Palm Beach Post*.)

Max Greenberg, Hardware Store Owner
Much of South Florida was still a tropical wilderness in 1912 when Austrian-born Max Greenberg opened Pioneer Hardware, a small general store providing supplies, hardware, furniture, and linens for the newly formed town of Lake Worth. Greenberg moved his business to Clematis Street in West Palm Beach after the killer hurricane of 1928. The Greenberg family provided exceptional customer service and stayed attuned to the community's needs. (Courtesy of the Historical Society of Palm Beach County.)

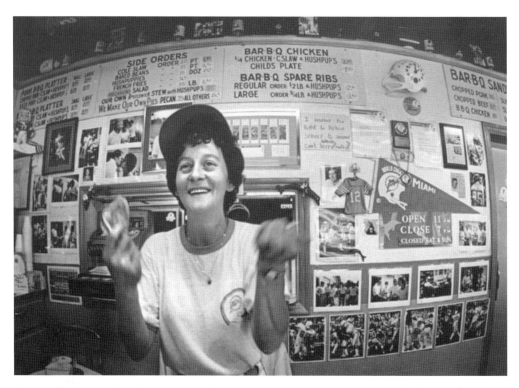

Donna Psaropoulos, Restaurant Owner
The aroma of delicious barbeque brought guests to Topfer's Barbecue on Dixie Highway. Owner Donna Psaropoulos, known as "Dolphin Donna," served her barbecue meals with guests surrounded by her immense collection of Miami Dolphins memorabilia. Over 16 years, Dolphins fans would gather at the eatery to enjoy the food and talk football. (Courtesy of the *Palm Beach Post*.)

J.C. Harris, Men's Clothing Store Owner
James C. Harris opened his first West Palm Beach men's clothing store in 1903 on Datura Street before moving to its final location on Clematis Street. This West Palm Beach institution was family owned for more than a century until its demise in 2013. Harris is credited with inventing the tasseled loafer, still made by G.H. Bass & Company. He became the first Palm Beach County superintendent of public instruction in 1909. (Courtesy of the *Palm Beach Post*.)

Patrick Howley, Restaurant Owner

One of West Palm Beach's favorite diners, Howley's Restaurant, hails to 1950 when Patrick J. Howley started dishing up comfort food made from scratch. The iconic eatery at 4700 South Dixie Highway has new owners, but the West Palm Beach landmark still sports the same terrazzo floors, Formica-topped tables, soda fountain with swivel stools, and an open grill as it did in the mid-20th century. (Authors' collection.)

Ron Wiggins, Newspaper Columnist

Popular newspaper columnist and author Ron Wiggins entertained Palm Beach Post readers for over three decades. From 1974 to 2006, Wiggins amused and enlightened with his words and wit. He brought readers along on his outdoor adventures. Today, Wiggins, an avid outdoorsman and traveler, tutors schoolchildren in reading and continues to delight readers with his humorous books. (Courtesy of the *Palm Beach Post*.)

Bill Gordon, Television News Anchor

Bill Gordon began his broadcasting career as news director at radio stations in Texas and Florida, coming to West Palm Beach in 1948 to work at WEAT radio. He became news anchor at WPTV in 1961 and was on air until 1978. WPTV's program *News with Bill Gordon* garnered the highest local news ratings for decades. (Courtesy of the *Palm Beach Post*.)

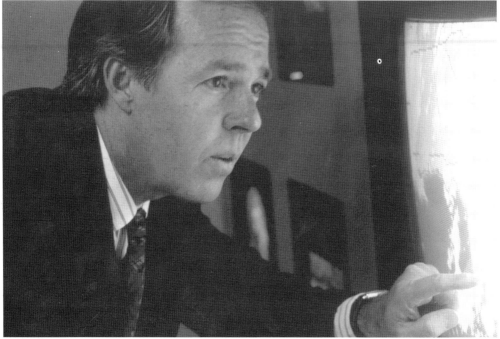

John Matthews, TV Meteorologist

John Matthews, chief meteorologist for WPEC, has been on air longer than any other television journalist in Palm Beach County history. Matthews came to the West Palm Beach television station in 1976 after having worked in Detroit, Michigan. He was a news anchor for several years before moving to meteorology, where his calm voice guides viewers and listeners through many tropical weather systems. (Courtesy of the *Palm Beach Post*.)

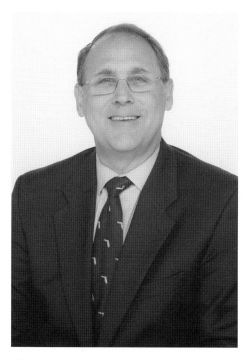

Eliot Kleinberg, Newspaper Reporter and Historian

Journalist and author Eliot Kleinberg is a South Florida native and community news reporter for the *Palm Beach Post*. He has worked as a journalist for nearly 40 years, with more than 25 of those years at the *Post*. In addition to news reporting, Kleinberg writes about Florida history and is the author of the popular weekly Post Time history column, and has published over 10 books. Kleinberg's father is the well-known Miami area journalist Howard Kleinberg. (Courtesy of Eliot Kleinberg.)

Sunny Quinn, Radio Personality

One of the most familiar voices on South Florida radio in the 1980s and 1990s, television and radio personality Sunny Quinn began her radio career at Foxy 1040 AM in Delray Beach. She entertained listeners at WEAT Sunny 104.3 FM with her *Sunny After Dark* program before landing a morning gig at WZZR 92.7 FM. Quinn, an author, voiceover artist, and broadcasting schoolteacher, is married to musician Don Brewer, drummer/singer of Grand Funk Railroad. (Courtesy of the *Palm Beach Post*.)

Jim Sackett, Television News Anchor
Jim Sackett was a familiar face on local television, anchoring the news desk at WPTV for more than 30 years. Sackett started at WPTV in 1978, and station management promoted Sackett to anchor in 1980. He is most remembered for his "Thursday's Child" segments featuring local children in need of adoptive families. Numerous children found their forever homes because of his efforts. (Courtesy of the *Palm Beach Post*.)

Frank Cerabino, Newspaper Columnist
Since 1991, *Palm Beach Post* columnist Frank Cerabino has delivered journalistic wit and sass to readers in his news columns and editorials. Cerabino's humor extends to his fictional South Florida condominium life books, *Shady Palms* and *Pelican Park*, first published in serial form by the *Palm Beach Post*, followed by his 2001 autobiography, *Writing Like a Taller Person*. In addition to his journalistic talent, Cerabino charms audiences and elicits laughs by playing the accordion. Cerabino even tweets humorous one-liners on Twitter under the handle @FranklyFlorida. (Courtesy of the *Palm Beach Post*)

Capt. Jack Smith, Television Fishing Reporter

Capt. Jack Smith moved to Florida from New Jersey in 1950 and had a half-hour live radio broadcast. Captain Jack was also famous for his daily *Five on 5* evening television fishing program. In addition, he was a fishing columnist for the *Delray News* and the *Lake Worth Herald*. Prior to coming to Florida, Captain Jack found employment as a professional boxer, a charter boat captain, and a lure manufacturer. The *Captain Jack* show was sponsored in part by Pepsi. To the delight of the viewers, Jack's bird loved to drink Pepsi. (Courtesy of West Palm Beach Fishing Club.)

Greg and John Rice, Real Estate Brokers and Television Personalities

Born in 1951 at St. Mary's Hospital, twins John and Greg Rice rose to fame in Palm Beach County and nationally for their business savvy, humorous television commercials, motivational speaking, and exceptional height of two feet, 10 inches. The Rice twins attended Palm Beach High School, where they played in the band, and the outgoing duo found success as realtors, marketing directors, actors, and community spokespersons. The brothers held the world record as the shortest living twins until John's passing in 2005. (Courtesy of Greg Rice.)

73

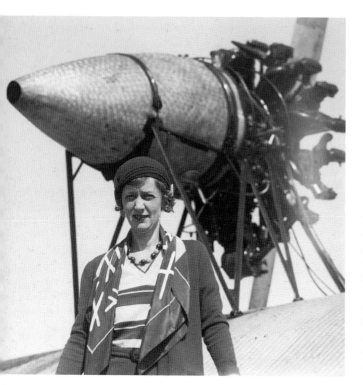

Grace K. Morrison, Secretary and Aviation Promoter
Sport aviatrix Grace K. Morrison, the first woman to fly solo in Palm Beach County, learned to fly in 1932. Morrison, a daring pilot and secretary for the architectural firm of Treanor & Fatio, served as president of the Palm Beach County airport commission and rallied successfully for a West Palm Beach airport. Morrison suffered fatal injuries when an automobile she was driving flipped over in a single-car highway accident near Titusville. Authorities named the airport, dedicated three months after her September 1936 death, Grace Morrison Field. The airport served as an Army base in World War II, and the little regional airfield is now Palm Beach International Airport. (Courtesy of the Historical Society of Palm Beach County.)

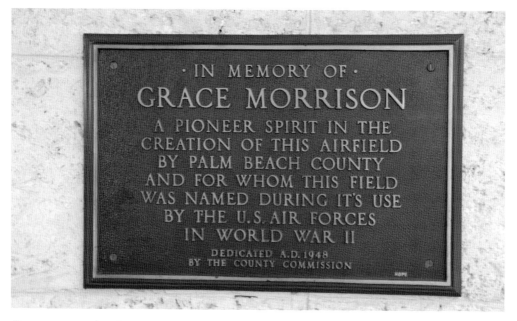

Commemorative Plaque at Palm Beach International Airport
The county commission placed this plaque at the airport in 1948 to commemorate Grace Morrison and the airport's use as an Army airfield during World War II. (Authors' collection.)

Marshall Edison "Doc" Rinker Sr., Concrete Products Company Founder
Doc Rinker Sr. launched Rinker Rock & Sand Co. in 1926 with a dump truck, shovel, and determination. Rinker built his Rinker Materials empire of ready-mixed concrete and block on a strong business ethic and laid the foundation of much of South Florida. Rinker's philanthropy extends through many layers of West Palm Beach generations with his $55-million Marshall E. Rinker Sr. Foundation. The foundation donated significant funds to Palm Beach Atlantic College, where the business school bears his name; the Vera Lea Rinker Hall, which honors his wife; and the Marshall E. Rinker Sr. Playhouse at the Kravis Center. (Courtesy of the *Palm Beach Post*.)

Art Rooney, Sports Team Owner
With sports as the cornerstone of the family business, Art Rooney purchased the Palm Beach Kennel Club in 1970 to add to his sports empire, which includes the Pittsburgh Steelers. Nicknamed the "Chief," together with his five sons, the Rooneys have been at the center point of sports and politics in Palm Beach County. (Authors' collection.)

Kay Rybovich, IWFA Founder

In 1955, Katherine "Kay" Jordahn Rybovich, wife of John Rybovich Jr., cofounded the International Women's Fishing Association (IWFA). During the International Sailfish Tournament, Kay and friends Ginny Sherwood and Denny Crowninshield decided they loved fishing and wanted to fish more often than the occasional ladies' day. Sherwood worked with an attorney to have the papers drawn up. Within a week of the club's formation, 30 women anglers attended a meeting. The purpose was to promote fishing tournaments in many parts of the world. At its peak, the IWFA boasted over 500 members. (Courtesy of Kay Rybovich.)

John Rybovich Sr., Yacht Designer and Builder

Carpenter and cabinetmaker John "Pop" Rybovich Sr., a Slovakian immigrant, settled in West Palm Beach in 1912. Rybovich, a commercial fisherman, repaired boats and skiffs for local fishermen before designing and building the first modern sport-fishing boats. His fine carpentry skills produced deluxe designs. Rybovich's entrepreneurship gave rise to Rybovich Boatworks, a world-famous luxury custom yacht business created by his sons John Jr., Tommy, and Emil. (Courtesy of the Rybovich Family Archives.)

The Rybovich Boat Company
The advertisement at the top shows the full range of marine services offered by the John Rybovich Company. Today, the Rybovich Boat Company, owned by Wayne Huizenga Jr., is world-renowned for their refit and repair of mega luxury yachts from their marina and campus on the Intracoastal Waterway. (Above, courtesy of the Rybovich Family Archives; below, authors' collection.)

Worley L. Sewell, Hardware Store Founder
Arriving during the 1920s boom years, Worley L. Sewell opened his hardware store on Clematis Street in 1924. He initially sold hardware and household goods but later switched exclusively to hardware. Sewell opened stores in Lake Worth, Riviera Beach, and Fort Pierce. The company continues today with three stores catering primarily to contractors and builders. Sewell's famous slogan is "Try Sewell . . . he might have it." (Both, courtesy of Sewell Hardware.)

CHAPTER FIVE

Community, Education, and Spritual and Medical Leaders

A sense of community is one of the strongest ties that binds together the diverse people who call West Palm Beach home. Organizations and clubs such as the Boy and Girl Scouts, environmentalists, historians, archaeologists, other professionals, and volunteers give their time and talent to community projects, make improvements, and leave legacies. West Palm Beach has seen difficult times through segregation and the civil rights movement and came through them as a stronger and more vibrant community. The building blocks of education begin with the realization that an educated public gives the best chance of a successful community. Those who organize, teach, and lead local schools, colleges, and universities make that chance a reality, and West Palm Beach led the way for the entire state in having the first public community college, where all could gain an accessible and affordable education.

In its infancy, the West Palm Beach settlement made do with visiting ministers, and church services were held in homes, gardens, and the schoolhouse. Congregations built churches, and new denominations sprouted as the city grew. Today, West Palm Beach is home to many dozens of churches and synagogues. The local hospitals, physicians, and medical leaders have grown and transformed along with the city, from a tiny five-bed hospital to today's state-of-the-art medical facilities. The Palm Beach Zoo grew out of one man's love of animals from a small petting zoo and park to today's beautiful zoo and gardens.

West Palm Beach's cultural venues grew due to the generous support and financial gifts from benefactors, grants, tax dollars, philanthropists, and endowments. This chapter highlights a number of familiar names associated with buildings, parks, roadways, and theaters as well as the names of people who are not generally well known but who have made a significant impact upon the city.

Nathaniel Adams, Scout Leader

Civic-minded Nathaniel Adams, born in Bermuda and raised in Nassau, Bahamas, settled in West Palm Beach in 1931 with his wife, Ruth. At a time of segregated scouting activities, Adams, known by most simply as "Nat," formed a Boy Scout troop for black children and served as field commissioner and conference and camp director. His soft-spoken leadership resulted in his appointment as district executive of the Gulf Stream Council of the Boy Scouts, a position in which he served for 38 years. In 1983, the city named the park at 568 Fifteenth Street Nathaniel J. Adams Park in his honor. (Authors' collection.)

Clarence L. "Carl" Brumback, Physician and Health Director

"The People's Doctor" played a vital role in improving the health of Palm Beach County residents. Serving as the first county public health director, Dr. Brumback lobbied for healthcare for the poor, including helping to pass the 1962 Migrant Health Act. He saw health hazards such as dumping raw sewage in the Intracoastal Waterway and had county officials work to correct them. In the 1950s, Dr. Brumback led efforts to make sure children received the polio vaccine. (Courtesy of the *Palm Beach Post*.)

Marshall M. Criser Jr., University President and Attorney
Marshall McAllister Criser Jr. served as president of his alma mater, the University of Florida (UF), from 1984 to 1989. Criser moved to West Palm Beach with his parents in 1941. He attended Palm Beach High School, followed by law school at UF, where he worked in the cafeteria to help pay for school. He was a partner in the law firm of Gunster, Yoakley, Criser, and Stewart for over 31 years before accepting the position as the eighth president of UF and one of only two alumni to hold that title. (Courtesy of the University of Florida.)

Christian Davenport, Archaeologist
Christian DeForest Davenport is Palm Beach County's first historic preservation officer and archaeologist. He has contributed to documenting the 300 known archaeological sites across the county, the oldest between 8,000-11,000 years old. There are also over 13,000 potentially historically significant structures. Davenport leads teams of trained archaeologists and students in documenting and preserving these archaeological sites. Across the globe, there is a growing ambivalence to outright hostility toward preserving humanity's history. The largest challenge to his work is that the majority of the populace is from somewhere else. Thus, what they consider important history only exists "back home." (Courtesy of Christian Davenport.)

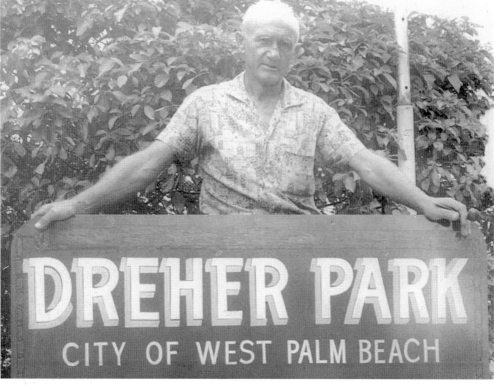

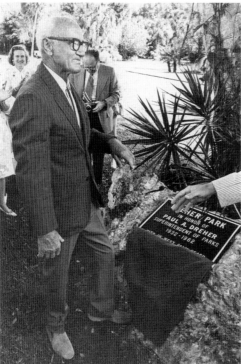

Paul Dreher, Parks Director and Zoo Founder

Known as the "Johnny Appleseed of West Palm Beach," Paul Dreher came from his native Germany to seek his fortune in Florida. Trained as a horticulturist, Dreher started his own nursery in Boynton Beach. After leaving Boynton Beach in 1931, he worked for the West Palm Beach public-works department. He became the city's first parks director and began his legendary tree planting efforts across the city. In 1951, he urged the city to buy a piece of swampy land next to the city dump for $100. Dreher transformed that swamp into today's Palm Beach Zoo and Dreher Park. (Above, courtesy of Palm Beach Zoo; left, courtesy of the *Palm Beach Post*.)

**Watson B. Duncan III,
Professor of Literature**

As the most beloved professor at Palm Beach County's first higher-education institution, Watson B. Duncan III left his mark on West Palm Beach and its students. Palm Beach Junior College (today Palm Beach State College) hired Duncan in 1947 to teach English at its Morrison Field campus. Duncan inspired locals Burt Reynolds and Monte Markham to their stellar acting careers in motion pictures and television. His teaching of Shakespeare and British literature inspired many students to theater and teaching careers. Duncan passed away in 1991, ending his 43-year career as professor of literature. (Both, courtesy of Palm Beach State College.)

**Howell Watkins and
Joe A. Youngblood, Educators**
At the height of the Great Depression, two men launched an idea that created the largest higher-education institution in Palm Beach County. In the 1930s, few parents had the means to send their children away to college in Tallahassee or Gainesville, so Howell Watkins (top) and Joseph Youngblood (bottom) founded Palm Beach Junior College, where students could stay local and study. A building on the Palm Beach High School campus was repurposed for teaching the basic courses that make up the first two years of a bachelor's degree. Youngblood was the superintendent of public instruction, while Watkins was principal of Palm Beach High School. Classes began in 1933, with 41 students enrolled. The single-building college has grown into an institution with five campuses and over 49,000 students now known as Palm Beach State College. (Both, courtesy of Palm Beach State College.)

Dr. Dennis P. Gallon, College President
A lifelong educator and Florida native, Dr. Dennis P. Gallon led Palm Beach State College (PBSC) for 18 years, through the largest program and enrollment growth in its history. Under Dr. Gallon's leadership, more than 75,000 students completed programs ranging from certificates to baccalaureate degrees, a number greater than the preceding 64-year history of the college. (Courtesy of Palm Beach State College.)

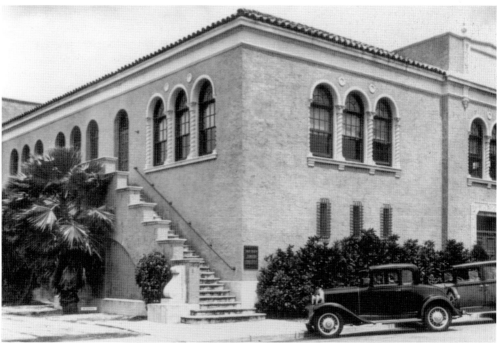

First Palm Beach Junior College Building
On the campus of Palm Beach High School, this two-story building designed by William Manly King became the first Palm Beach Junior College building. The structure was listed in the National Register of Historic Places in 1991. (Courtesy of Palm Beach State College.)

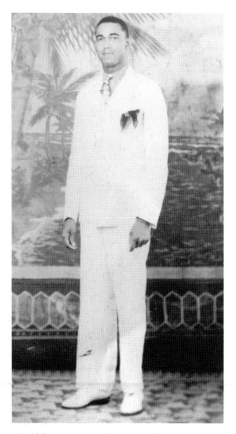

U.B. Kinsey, Teacher and Principal

Popular educator and longtime school principal of Palmview Elementary School (formerly Industrial High School), Ulysses Bradshaw Kinsey lived in West Palm Beach from the time he was eight years old until his death in 2005 at the age of 86. Kinsey, known to students as Mr. Kinsey and to his family and friends as U.B., played a vital role in the tumultuous road to civil rights and race equality for teachers and minorities. Kinsey won in the struggle for equal pay for black teachers, with future US Supreme Court justice Thurgood Marshall serving as his attorney. Kinsey's teaching career spanned nearly five decades. Upon his 1989 retirement, Palmview School was renamed U.B. Kinsey Elementary School in his honor. (Courtesy of the *Palm Beach Post*.)

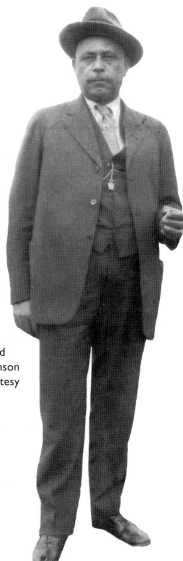

James Jerome "Cracker" Johnson, Entrepreneur and Community Leader

Renowned businessman James Jerome Johnson, also known as "Cracker" Johnson, was one of West Palm Beach's successful businessmen in the 1920s, 1930s, and 1940s. Johnson, a mixed-race bootlegger and numbers runner, earned his nickname because he could pass as white. He built a house in an area where the black elite lived called Freshwater and prospered in the real estate boom of the 1920s. He built the Dixie Theater on Rosemary Street, made money on rental properties and personal loans, and opened a segregated night club. Johnson was killed in 1946 while trying to break up a fight. (Courtesy of the *Palm Beach Post*.)

Raymond F. Kravis, Philanthropist

West Palm Beach acquired one of its crown jewels in 1992 when the Raymond F. Kravis Center for the Performing Arts opened. The center, built with public funds and millions in contributions from Kravis's friends, opened fully funded and was named in his honor. Kravis, who retired to West Palm Beach after a long career in the oil and gas business, served on the board of several service organizations, including the Boy Scouts of America. Architect Eberhard Zeidler designed the performing arts center (pictured below), which first opened its doors in 1992. The main hall seats 2,195 patrons; smaller venues seat from 170 to 289, and an outdoor amphitheater seats 1,400. (Right, courtesy of the *Palm Beach Post*; below, authors' collection.)

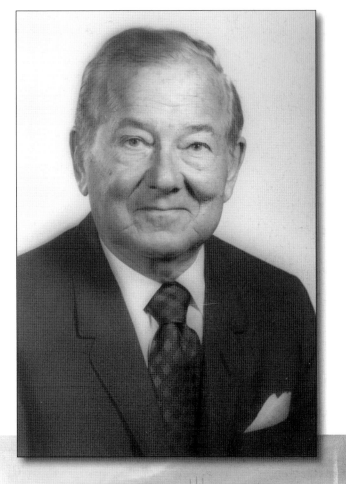

Samuel H. Hairston "Jack the Bike Man," Community Leader

What started as a simple act of kindness to a needy neighborhood child blossomed into a fulltime children's bicycle charity. After Samuel H. "Jack" Hairston III fixed the brakes on a youngster's bicycle in 1999, other neighborhood children knocked on his door for help. After a local news station aired a clip of Hairston delivering a refurbished bicycle to a child, people and businesses donated used bikes and money to the cause. Since then, the operation has grown into Jack the Bike Man's Children's Bicycle Charity. Partner organizations, donors, and an army of volunteers collect, repair, and distribute thousands of bicycles and helmets to underprivileged children each year. (Authors' collection.)

Jack the Bike Man Mural
This striking mural helps customers find Jack's Florida Avenue warehouse, where refurbished bicycles can be purchased to help support his children's bicycle charity. (Authors' collection.)

Gene Joyner, Horticulturist and Educator

Nationally known horticulturist Gene Joyner, former University of Florida Extension urban horticulturist for 35 years, transformed the land where he grew up into a private nonprofit tropical garden. Established in 1970, Joyner's unique, peaceful oasis, called Unbelievable Acres Botanical Gardens, contains 2,000 varieties of plants and more than 160 varieties of fruit trees. Joyner narrates guided tours of his lush tropical rainforest nestled off Jog Road near Southern Boulevard and shares his vast gardening knowledge in bimonthly newspaper and radio spots. (Both, courtesy of Jan Norris.)

Marvin Mounts Sr., County Agricultural Agent

Palm Beach County's first assistant agricultural extension agent, Marvin Umphry Mounts Sr., toured the vast county educating farmers on modern farming methods. Known widely as "Red Mounts," he held the position of county agricultural agent from 1929 until his retirement in 1965. During that time, agriculture became one of Palm Beach County's largest industries. Mounts founded the first chartered 4-H Club in Florida, helped to establish the Audubon Society, and served on many farm and horticultural committees until his death in 1965. The Mounts Botanical Garden on Military Trail is named for him, and he was named a Great Floridian in 2000. (Authors' collection.)

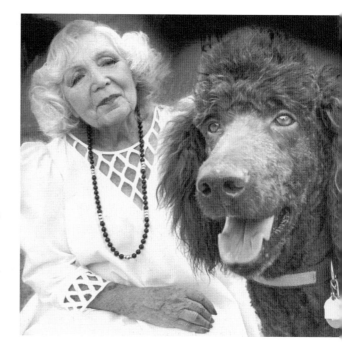

Gertrude Maxwell, Animal Rights Philanthropist

Community leader and animal rights activist Gertrude Maxwell donated her time and money to save the lives of domesticated animals. Her work as an outspoken defender of animals gave a voice to the voiceless animals that face euthanizing if not adopted. Maxwell founded Save-A-Pet Inc. in 1972 and the Save-A-Pet Guild in 1992. She helped control the feral cats in Palm Beach, saved retired racing greyhounds, and brought awareness to the plight of stray animals. Maxwell passed away three months before her 100th birthday in 2011. (Courtesy of the Historical Society of Palm Beach County.)

Arthur and Sydelle Meyer, Philanthropists
The Meyer Amphitheater on Flagler Drive bears the name of generous philanthropists Arthur I. Meyer and his wife, Sydelle. Meyer, a lawyer and businessman from New York, invested wisely and retired to Palm Beach in the late 1970s. The Meyers donated time, energy, and money to the West Palm Beach and Jewish communities in Palm Beach County. Their names also grace a wing at the Norton Museum of Art, the Arthur I. Meyer Day Academy School at the Jewish Community Center, and the Meyer Auditorium at the Dreyfoos School of the Arts. (Courtesy of the *Palm Beach Post.*)

Judy Moore, Nurse and Soccer League Founder
Registered nurse Judy Moore was instrumental in founding the youth soccer league in West Palm Beach, both as a mentor and coach. From 1981 to 1983, her soccer teams were the city champions. More than a few West Palm business leaders and professionals were introduced to sports competition on the South Olive Avenue soccer fields under her enthusiastic approach and support for youth activities. (Courtesy of the Moore family.)

Richard and Pat Johnson, Developers and Philanthropists

Richard S. "Dick" Johnson and his wife, Pat, both members of distinguished local pioneer families, have a long history of supporting philanthropic causes in Palm Beach County. The Johnsons donated $1.25 million to the history museum in the restored 1916 courthouse. Johnson, an astute business owner, developed the first business high-rise building on the water. His Flagler Center housed his insurance company, Cornelius, Johnson, and Clark Inc., and Flagler National Bank. He served as the longtime president of St. Mary's Medical Center. Johnson passed away suddenly in 2012; his legacy lives on in the Richard and Pat Johnson Palm Beach County History Museum. The generosity of the Johnson family and other benefactors allow the museum to offer free admission. The museum, opened in March 2008, features two main exhibit areas: a permanent exhibit area featuring people and places, and a rotating temporary exhibit area featuring themed exhibits. (Left, courtesy of the Historical Society of Palm Beach County; below, authors' collection.)

1916 COUNTY COURT HOUSE
THE RICHARD AND PAT JOHNSON
PALM BEACH COUNTY HISTORY MUSEUM
COUNTY GOVERNMENT OFFICES
FUNDED BY: PALM BEACH COUNTY BOARD OF COUNTY COMMISSIONERS &
STATE OF FLORIDA, DIVISION OF HISTORICAL RESOURCES

James R. Knott, Judge and Historian

Judge James R. Knott was considered the dean of Palm Beach County history. He came to Palm Beach County and practiced law before serving as circuit court judge from 1956 to 1977. A native Floridian whose roots in Florida trace back to the 1830s, Judge Knott had a deep passion for history and wrote several books on the subject. Knott said, "It gives people a sense of identity, a sense of place and a sense of belonging to a community. It places people where they are in the stream of humanity." (Courtesy of the *Palm Beach Post*.)

Debi Murray, Chief Curator and Historian

A Palm Beach County native, Debi Murray has served as chief curator, archivist, cataloger, and researcher at the Historical Society of Palm Beach County since 1999. Murray's passion for history is evident in the hours she contributes her time and talents to documenting and promoting Florida history. Local and statewide journalists, educators, and documentary producers tap into Murray's vast bank of knowledge and propensity for producing primary resources related to Palm Beach County history. She is the author of several local history books. (Courtesy of the Historical Society of Palm Beach County.)

James Ponce, Raconteur and Historian

James Ponce has lived in West Palm Beach since the 1950s; however, his family has been in Florida for close to 200 years. Ponce retired as assistant manager of the Breakers hotel in 1982; he then started his second career as historian for the Palm Beach Chamber of Commerce and the Breakers Hotel. In his late 90s, Ponce still leads guided tours of the Breakers Hotel, even playing Henry Flagler himself on occasion. Ponce was the recipient of the 2011 Palm Beach County Convention and Visitors Bureau Providencia Award. (Courtesy of the *Palm Beach Post*.)

Dr. Reginald Stambaugh, Physician and Community Leader

A fifth-generation Floridian, Dr. Reginald J. Stambaugh, a successful ophthalmologist and inventor of several medical procedures, played a key role in saving the high school from which he had graduated in 1947 from demolition. His passion, perseverance, and leadership in historical preservation led to the renovation of Palm Beach High School into the Dreyfoos School of the Arts. Dr. Stambaugh served as Historical Society of Palm Beach County president from 1995 to 1998 as well as president of the Historical Foundation of Palm Beach County and was very involved in saving the 1916 courthouse. (Courtesy of the Historical Society of Palm Beach County.)

Haley and Dr. Alice F. Mickens, Community Leaders

The Mickenses were at the heart of the city's African American community for almost a century. Haley Mickens and his wife, Dr. Alice F. Mickens, lived at Fourth Street and Division Avenue for decades. Their home was the place where African Americans could board when shunned by hotels and where dignitaries stayed while in town. Celebrities such as Louis Armstrong, Count Basie, and Nobel Peace Prize recipient Ralph Bunche stayed at the Mickens home. Reverend Mickens founded the Bethel Church in Palm Beach, which became the Payne Chapel AME in West Palm Beach. Alice lived in the house from 1917 until her death in 1988 at age 99. (Courtesy of the *Palm Beach Post*.)

The Mickens House

The Mickens House at 801 Fourth Street is one of the oldest houses in West Palm Beach. The house is American four-square in design with shaded windows that are ideal for a sub-tropical climate. In 1985, the house was listed in the National Register of Historic Places. (Authors' collection.)

Jess Moody, Minister and Founding College President

In 1961, Dr. Jess Moody, an early member of the Billy Graham evangelistic team, answered the call as pastor of First Baptist Church of West Palm Beach. Seven years later, his vision for a Christian college, Palm Beach Atlantic College (now Palm Beach Atlantic University), opened with 84 students and Moody as its founding president. During his tenure, the campus grew with the addition of the Chapel by the Lake and a new church sanctuary. Today, Palm Beach Atlantic University serves over 3,600 students and offers 51 undergraduate and graduate majors in areas such as business, leadership, psychology, and pharmacy. (Courtesy of Palm Beach Atlantic University.)

Dr. Donald Warren, Physician

Florida native Dr. Donald Eugene Warren had a 40-year career as a cardiologist and was on staff at St. Mary and Good Samaritan Hospitals. Dr. Warren, founding chairman of Palm Beach Atlantic University (PBAU), played a key role in raising funds for West Palm Beach's magnificent downtown university. The Warren Library at PBAU bears his name in honor of his role as university founder, author, storyteller, and upstanding community leader.(Courtesy of Palm Beach Atlantic University.)

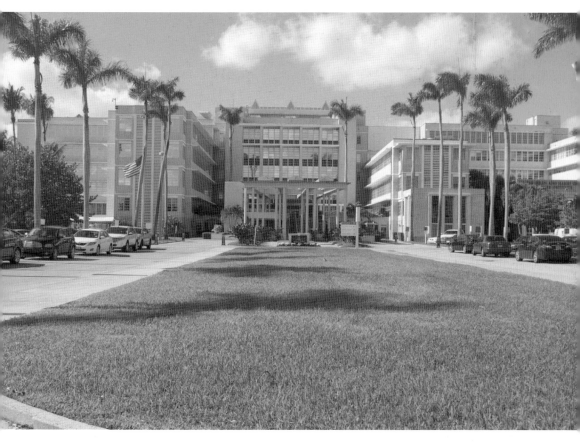

Dr. William E. Van Landingham, Physician and Health Director

West Palm Beach's first hospital opened in 1914, a five-bed cottage with an operating room, kitchen, nurse's room, and bathroom. Dr. William Ernest Van Landingham arrived in 1918 after a 13-year medical practice in Fort Pierce. He saw how inadequate the tiny hospital was and championed for developing a full-service hospital. Good Samaritan Hospital opened in 1920 with 35 beds. Known familiarly as "Dr. Van," he served as Good Samaritan Hospital's superintendent from 1924 to 1926 and was the city's physician and health director for over 20 years, until he became county physician in 1944. His patients described him as a good old-fashioned country doctor. Dr. Van Landingham was one of 19 founding members of the Palm Beach County Medical Society. In 1919, the doctors approved a fee schedule in which a house call was $2, night calls $3, and baby delivery $30. Good Samaritan Hospital remains among the area's leading healthcare providers and soon celebrates its 100th year of service. (Authors' collection.)

Sue Twyford, SunFest Executive Director

In the 11 years that she served as executive director of SunFest, Sue Twyford (shown at center with Jon Stoll of Fantasma Productions) made a lasting impact on the cultural and artistic landscape of Palm Beach County. Under her vision and leadership, the modest two-day event grew into a popular five-day festival attracting renowned national acts and hundreds of thousands of attendees. Sue Twyford passed away unexpectedly in 2003, leaving her husband, Tom, and two young sons. With her sudden death also came the gift of life, as Sue was an organ donor. Her legacy continues with students attending college on SunFest scholarships and a downtown SunFest park. (Courtesy of Tom Twyford.)

2013 LEONARD BRYANT PHOTOGRAPHY

Tom Twyford, Fishing Club Executive Director

Tom Twyford, shown here in 2013 running a Silver Sailfish Derby captains' meeting, has served as executive director of the West Palm Beach Fishing Club since 1988. During his tenure, the club has grown by nearly 200 members. The club, founded in 1934 in the midst of the Great Depression, is one of the oldest and largest fishing clubs in the United States. It developed the sailfish release flag so that crews could display successful catches while releasing the fish. The popular KDW (Kingfish, Dolphin, Wahoo) tournaments attract hundreds of anglers each year. (Courtesy of Leonard Bryant.)

CHAPTER SIX

Peacemakers, Lawyers, and Politicians

West Palm Beach prospered during its first century due to its determined early townspeople and the valiant efforts of inaugural town leaders and officials as well as the brave endeavors of its law enforcers. In the 1890s, the term Wild West epitomized the face of West Palm Beach. A wide-ranging assortment of people helped to tame and shape the small frontier town into the big city of today. The guidance and wisdom of the city leaders, politicians, protectors, and city servants highlighted in this chapter represent the many diverse leaders who sacrificed, guided, and shaped West Palm Beach into today's metropolis. This chapter salutes law enforcement and fire rescue leaders whose daily actions keep West Palm Beach a safe place to live, work, and play. The city has produced a bevy of trailblazers who serve the city on a local level and represent the area's interests in the Florida Senate and US House of Representatives. The lawmakers and lawyers highlighted here are a sampling of the men and women at the backbone of the community who shaped the law and gave back to the community with time and money. High-flying naval aviator David McCambell and moon-walking astronaut Edgar Mitchell prove that there are no limits to what a person can achieve in his or her lifetime.

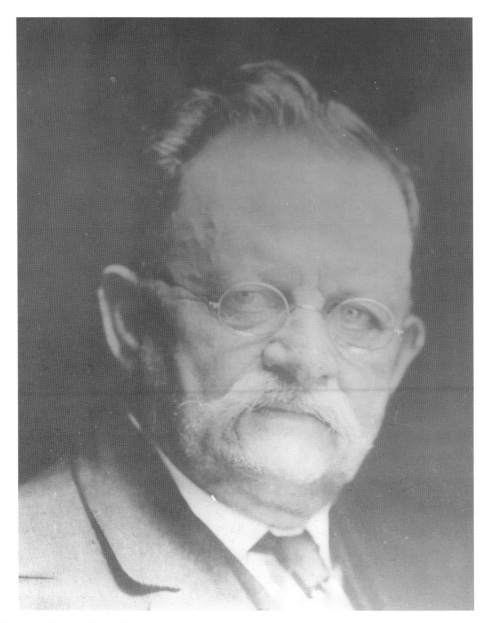

George Baker, Sheriff

Palm Beach County's first sheriff, George B. Baker, fearlessly served as lawman from 1909 until his death in 1920. Upon Baker's death, his son Robert succeeded him as sheriff. During his tenure as sheriff, he pushed for the first traffic laws in West Palm Beach and patrolled the streets wearing a beaver Stetson and driving a seven-passenger Studebaker. Numerous history books describe his role in attempting capture of the infamous John Ashley of the Ashley Gang after Ashley allegedly murdered Desoto Tiger, son of Seminole chief Tommy Tiger. Once apprehended and jailed, Ashley escaped Baker's custody and continued terrorizing South Florida. Baker almost lost his job as sheriff when accusations of ignoring illegal gambling arose. Early West Palm Beach residents describe Baker, who also served as mayor of West Palm Beach from 1905 to 1907, as an easy-going man who gave to many charities, especially children's causes. (Courtesy of Palm Beach County Sheriff's Office.)

Rick Bradshaw, Sheriff
Rick Bradshaw, a former Marine and native of Lake Worth, joined the West Palm Beach Police Department in 1971 and rose through the ranks to be appointed chief in 1996. After retiring as chief of police, in 2005, Palm Beach County voters elected Bradshaw as sheriff, overseeing the county's largest law-enforcement agency. (Courtesy of Palm Beach County Sheriff's Office.)

Marvin U. Mounts Jr., Judge
Marvin Umphrey Mounts Jr. was born in West Palm Beach during the Great Depression. He graduated from Palm Beach High School, served in the Air Force, attended law school, and returned home to practice law. He served as county solicitor from 1964 until 1972, when county voters elected him circuit court judge. Mounts was the longest-serving elected official in Palm Beach County and one of the longest-serving in Florida history. (Courtesy of the *Palm Beach Post*.)

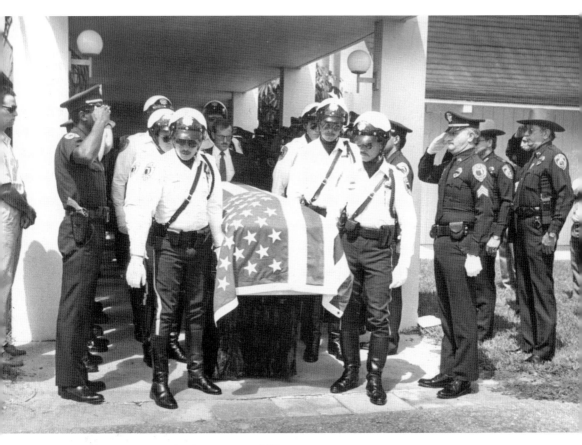

Brian Chappell, Law-Enforcement Officer

A traffic stop in August 1988 resulted in the death of 31-year-old police motorcycle officer Brian Heywood Chappell. Officer Chappell, a five-year veteran of the West Palm Beach force described by his friends and family as an avid sportsman and angler, was fatally shot in the heart at close range after pulling over a speeding pickup near Southern Boulevard and Dixie Highway. Chappell, who joined the department in 1983, had removed his bulletproof vest due to the oppressive mid-August heat and humidity. His killer was an escapee from a prison work-release program driving a stolen vehicle. Officer Chappell became the eighth West Palm Beach police officer to die in the line of duty. (Courtesy of the Historical Society of Palm Beach County.)

FALLEN OFFICERS OF WEST PALM BEACH

Thomas Morash	October 17, 2003	Clarence Leo Wagner	February 10, 1967
Brian Heywood Chappell	August 22, 1988	Festus Alvah Tatum Jr.	March 28, 1959
Robert Dennis Edwards	January 21, 1984	Lewis Allen Conner	August 7, 1937
William Harold Fletcher	April 6, 1967	Jack Grace Wadlington	March 31, 1935
David Richard Van Curler	April 6, 1967	William Morgan Payton	February 9, 1924

Fallen Heroes West Palm Beach Police Officers Memorial
In addition to Officer Chappell, nine other West Palm Beach police officers died in the line of duty as of this writing. This statue on Rosemary Avenue outside the Banyan Boulevard police station pays tribute to the fallen officers and to all of those brave men and women who protect and police all areas of the city. (Authors' collection.)

103

Harry Juergen, Firefighter
In more than a century of service, the West Palm Beach Fire Department has only lost one firefighter, Capt. Harry Juergen, who started with the department in 1921. He was a 20-year veteran when a training accident claimed his life. Juergen was practicing fighting a marine fire from a boat in the turning basin in Howard Park when his boat overturned. Though other firefighters attempted to help him, a frantic Juergen panicked and fought rescuers' efforts. His fellow firefighters launched boats on the small lake trying to find him after he went under. Juergen was finally found at the bottom of the lake, but resuscitation efforts failed. After the accident, fire officials required all firefighters to be able to swim. (Courtesy of the *Palm Beach Post*.)

Fire Hall, W. PALM BEACH, Fla.

The Flagler Alerts
West Palm Beach can lay claim to having the oldest fire department in South Florida. First organized in 1894, the Flagler Alerts were volunteers using fire equipment donated by Henry M. Flagler. As the town and the department grew, Flagler donated a lot, and the city built a new fire station in 1905, seen in this 1910 postcard. The department officially changed its name to the West Palm Beach Fire Department in 1911. Developers restored the building to its original appearance, and today it houses offices and a restaurant. (Authors' collection.)

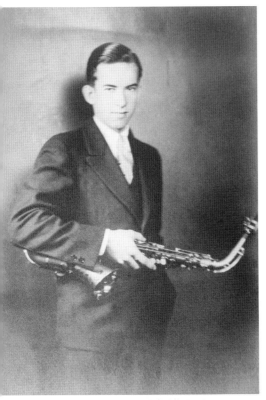

"Banzai" F.A. Currie, Judge and Musician
Banzai Currie, son of George Graham Currie and Lulu Angevine Currie, was born Frances Angevine Currie. A Japanese nurse gave the name Banzai to the baby, and the name remained with him. Currie is most remembered as a longtime county judge and creator of the Palm Beach County small-claims court system—a model for other small-claims courts throughout the country. Raised in West Palm Beach, Banzai attended Palm Beach High, where he gained popularity in the school band. While attending the University of Florida from 1926 to 1932, Banzai led an orchestral band called Banzai Currie and His Floridians. The band toured Europe and played music on transatlantic cruise ships, earning Currie the moniker the "Lawrence Welk of the South." (Both, courtesy of Newell family.)

John B. Dunkle, Clerk of Courts

A pioneer Brelsford family descendent, in 1958, John Brelsford Dunkle became the youngest elected county official at age 30 when elected as clerk of courts, an office he served in for 33 years. He operated the office with such efficiency that in most elections he ran unopposed. He expressed dissatisfaction that technology improvements such as computers had taken away personal service from his office, grown from seven employees in 1958 to 670 at the time of his retirement in 1991. (Courtesy of the *Palm Beach Post*.)

Judge Joseph Farish, Attorney

One of the most successful lawyers of his generation, Judge Joseph D. Farish Jr. generously shared his wealth with philanthropic gifts to Palm Beach Atlantic University, the University of Florida (his alma mater), the Richard and Pat Johnson History Museum, the Malz Jupiter Theater, and other community endeavors. Farish, who passed away in 2010 at the age of 89, initiated many real estate ventures, including a funeral home, automobile dealership, and a cattle ranch. (Courtesy of Palm Beach Atlantic University.)

Lois Frankel, Representative and Mayor

Public service has been the calling for Lois Frankel. She arrived in West Palm Beach from New York in the 1970s and served 14 years in the Florida legislature before winning the 2003 West Palm Beach mayoral race. She served two terms in office and saw the transformation of downtown with a new city hall and library complex. In 2012, Frankel won election to the US House of Representatives, where she continues to serve West Palm Beach and surrounding areas. (Courtesy of the US House of Representatives.)

Paul G. Rogers, Representative

Paul G. Rogers served as congressman for the greater West Palm Beach area for more than two decades after he ran in a special election after the death of his father, Dwight L. Rogers, in 1955 and won. He then prevailed in 11 straight elections to serve in Congress. Rogers was an advocate for healthcare issues and was nicknamed "Mr. Health." Federal officials named the federal building and courthouse in West Palm Beach in his honor. (Courtesy of the *Palm Beach Post.*)

Harry Johnston, Attorney and Representative

A fifth-generation Floridian, Harry Johnston had a long career in public service before entering private law practice. Voters elected Johnston to the Florida Senate in 1974, and he became senate president in 1984. He won election to Congress in 1988 and served four terms before leaving in 1997. He also served on the Palm Beach Community College (now Palm Beach State College) board of trustees. (Courtesy of the *Palm Beach Post*.)

William Meredith "Bill" Holland, Attorney

Civil rights advocate Bill Holland Sr. initiated desegregation of Palm Beach County's public schools and championed for equal access to beaches, swimming pools, and golf courses by all people regardless of color. Holland, the first black attorney in West Palm Beach, filed a groundbreaking lawsuit in 1956, using his son as plaintiff, to allow black students the same school access as whites. Litigation lasted nearly 17 years until full implementation of integration in 1973. Palm Beach County's Fulton-Holland School District Service Center honors Holland. (Courtesy of the *Palm Beach Post*.)

Eva Mack, Health Educator and Mayor

Dedicated public-health nurse Eva Williams Mack moved to West Palm Beach in 1948 and became the city's first African American mayor in 1982. Mack, who lived in Pleasant City, was also an educator and the first health specialist for the Palm Beach County School Board, working with Dr. Clarence Brumback. She worked to get health classes and sex education into all the public schools. Mack served the community and helped build relationships connecting the black and white communities. (Courtesy of the *Palm Beach Post*.)

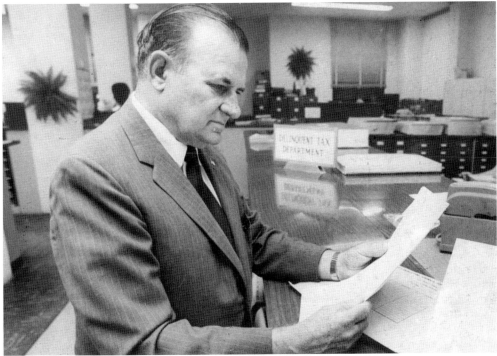

Lake Lytal Sr., County Commissioner

In 1975, former Palm Beach County Commissioner Lake Lytal, then 68 years old, jumped from a high-dive platform to celebrate a new park and county-run swimming pool bearing his name. Lake Lytal Park, on Gun Club Road in West Palm Beach, was named for Lake Lytal Sr., who graduated from Palm Beach High School in 1924 and served on the Palm Beach County Commission for a record-setting 32 years. Lytal, an advocate for the rights of women and minorities, supported recreational facilities and controlling the growth of Palm Beach County. His son Lake Lytal Jr., who graduated from Palm Beach High School in 1958, is a trial lawyer and active in community events and service. (Courtesy of the *Palm Beach Post*.)

David McCampbell, Naval Aviator

The US Navy's "Ace of Aces," David McCampbell grew up in West Palm Beach. He graduated from the naval academy in 1933 and became a career naval officer. He started flying for the Navy in 1937. As World War II started, McCampbell served on the USS *Wasp* before taking command of Fighting Squadron 15, which became one of the most highly decorated air squadrons of the war. McCampbell is the Navy's all-time ace, with 34 aerial victories. He earned the Medal of Honor, the Navy Cross, the Silver Star, the Legion of Merit, three Distinguished Flying Crosses, and the Air Medal. McCampbell retired to Lake Worth. (Courtesy of the State Archives of Florida.)

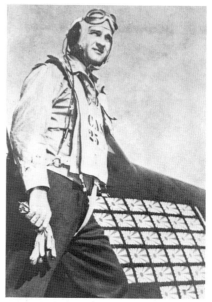

McCampbell Terminal, West Palm Beach

The terminal at Palm Beach International Airport was named in David McCampbell's honor in 1988. The terminal's third floor houses a permanent exhibit featuring a video, photographs, and a bust of McCampbell. (Authors' collection.)

Edgar Mitchell, Astronaut

A resident of the county since the 1970s, Edgar Mitchell (second from right) was the sixth person to walk on the moon. A Navy pilot, NASA chose Mitchell to be an astronaut in 1966. He blasted into history as a lunar module pilot on Apollo 14 in 1971. Mitchell has written books and articles on his experiences in space and his beliefs about human existence. His stepdaughter Kimberly Mitchell (far right) is a longtime West Palm Beach city commissioner. (Courtesy of Kimberly Mitchell.)

Pat Pepper, Mayor

Pat Pepper's stint as mayor of West Palm Beach from 1988 to 1989 was short-lived, but her impact upon the city is long-lasting. Pepper's energetic leadership and valuable connections brought rebirth to West Palm Beach as a cultural destination. Her strong character brought to life a much-needed cultural center, the Raymond Kravis Center for the Performing Arts. Its anchor helped transform and gentrify downtown West Palm Beach into a shopping and entertainment mecca with CityPlace, Clematis Street, and Flagler Park. Diagnosed with ALS (Lou Gehrig's disease) in 1993, Pepper passed away in 2003 at the age of 58. (Courtesy of the *Palm Beach Post*.)

Robert Montgomery, Attorney and Community Leader

Civil law attorney Robert Morel Montgomery Jr. was well known for winning verdicts resulting in over 65 settlements in excess of $1 million or more for his clients. Two of his most high-profile cases included an undisclosed settlement for Kimberly Bergalis, a young Fort Pierce woman who contracted HIV from her dentist in the late 1980s and the 1997 State of Florida's lawsuit settlement against the big tobacco companies. Montgomery also represented Theresa LePore, the Palm Beach County supervisor of elections, when she was facing public scrutiny and sued for the design of the 2000 election ballot. Montgomery and his wife supported the arts in Palm Beach County. (Courtesy of the *Palm Beach Post*.)

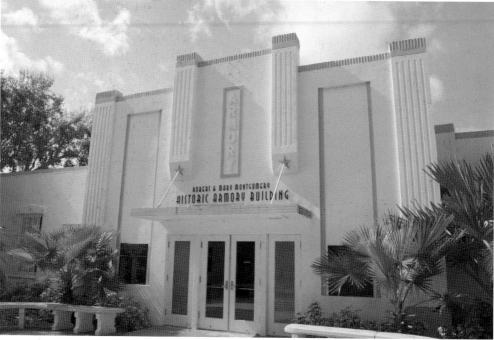

Armory Art Center

Robert Montgomery's law firm's $100,000 donation and matching community contributions helped refurbish the 1939 National Guard Armory, built by William Manly King, into the Armory Art Center in 1987. Today, the historic Art Deco–style building houses the Robert and Mary Montgomery Armory Art Center. (Authors' collection.)

Harvey E. Oyer III, Attorney

Harvey Oyer III is one of the most respected and revered residents of West Palm Beach. Oyer, a partner in the law firm of Shutts & Bowen, LLP, is a fifth-generation Floridian, active community leader, and an accomplished lecturer and writer. Oyer's great-great-grandfather, Hannibal Dillingham Pierce, brought his family to the West Palm Beach area in 1872 when it was an untamed wilderness. Oyer, who has a deep passion for keeping history alive, preserves those family stories in his series of children's books, *The Adventures of Charlie Pierce*. Oyer's list of community involvement is extensive; he served for seven years as the chairman of the Historical Society of Palm Beach County. He also serves as a director of the Chamber of Commerce of the Palm Beaches, a trustee of the South Florida Science Museum, a director of the Palm Beach Area Chapter of the American Red Cross, a director of the Palm Beach State College Foundation, and the Florida Senate president's appointee to the Great Floridians Committee. He has served as trustee of the Palm Beach United Way, a director of the Palm Beach County Cultural Council, and a fellow of the Duke of Edinburgh Foundation (United Kingdom). He rallied to save and preserve the 1916 West Palm Beach Courthouse. Because of Oyer's due diligence, today the former courthouse houses the Richard and Pat Johnson History Museum. When not working in or serving the West Palm Beach community, Oyer escapes to his ranch in Okeechobee with his wife and children. (Courtesy of the Oyer family.)

Nancy M. Graham, Mayor
The ground-level fountain and square where children cool off in Flagler Park on the waterfront bear the name of Nancy Malley Graham, West Palm Beach's mayor from 1991 to 1999. Graham, a lawyer and politician known as the city's first strong mayor, created popular events like Clematis by Night. Her visionary planning served as a catalyst for the downtown area's renaissance, morphing the waterfront park and surrounding area into a vibrant year-round destination for residents and visitors. (Left, courtesy of the *Palm Beach Post*; below, author's collection.)

Justice Barbara J. Pariente, Attorney

After completing her judicial clerkship, justice Barbara J. Pariente practiced law in Palm Beach County until appointment to the Fourth District Court of Appeal. Gov. Lawton Chiles appointed Justice Pariente to the Florida Supreme Court in 1997, and she served as chief justice from 2004 through 2006, only the second woman to hold that office. In 2008, Justice Pariente was inducted into the Florida Women's Hall of Fame. (Courtesy of the *Palm Beach Post*).

Jerry Thomas, Banker and State Senator

West Palm Beach native Jerry Thomas was born in 1929, graduated from Palm Beach High School, and served in the military during the Korean conflict. After college he headed the Florida Securities Commission, founding First Bank in Jupiter, Florida. His political career began in 1960 with his election to the Florida House of Representatives. He went on to the Florida Senate, serving from 1965 to 1972, the last two years as senate president. Thomas was instrumental in passing the Florida Sunshine Law and many environmental, education, and ethics laws. Jerry Thomas Elementary School in Jupiter and the Jerry Thomas Memorial Bridge to Singer Island were named for him. (Courtesy of the *Palm Beach Post*.)

Helen Wilkes, Hotel Owner and Mayor

In 1978, Helen Wilkes became West Palm Beach's first female mayor. Wilkes, a registered nurse turned entrepreneur, came to this area in 1952 at the age of 25 and founded a much-needed nine-bed nursing home. Over the years, her business savvy and determination resulted in a multimillion-dollar business and real estate empire. In 1973, she purchased and renovated the beautiful 1920s hotel El Verano on Flagler Drive and created the Helen Wilkes Resident Hotel. (Both, courtesy of the *Palm Beach Post*.)

CHAPTER SEVEN

The Memorable and the Notorious

As shown by daily newspaper descriptions, evening news stories, and historical accounts, West Palm Beach has experienced more than its share of comedy, tragedy, entertainment, catastrophe, and curiosities. The authors chose to forego some of the quirky "It could only happen in Florida" stories and those involving active court cases and police investigations.

Throughout its history, West Palm Beach has attracted its share of the notorious and strange. During World War II, rumors abounded that German officers from offshore submarines often dined at local restaurants. Gangsters reportedly built three large houses in the Northwood Hills area to act as lookout towers to spot their accomplices smuggling liquor through the Palm Beach Inlet during Prohibition. Whether these stories are true or not, they are part of the urban legends that abound in every community.

Some of the memorable and notorious subjects in this chapter include infamous accused murderess and Sunday school teacher Lena M.T. Clarke, who could have initiated the household phrase "going postal." No one who lived in the Palm Beaches in the 1950s can forget the shocking murders of stalwart circuit judge Curtis Chillingworth and his wife, Marjorie. A ghostly tale involves the infamous Riddle House, which some claim houses ghosts even when moved to a new location.

Memories of the terrifying, triumphant, and unexpected stories recounted in this chapter are juxtaposed with the unlikely underdogs, including a winning racing greyhound, and end with an endearing zoo figure whose story resonates with generations of West Palm Beach visitors and citizens.

Voda Adkins "The Dixie Witch"

People have heard many legends about the Dixie Witch, who was often seen walking along Dixie Highway during the 1970s, carrying her broomstick and chain-smoking cigarettes. Children would shun her, afraid to look at her matted hair and grizzled face. After almost 20 years on the streets, authorities finally took her to the county convalescent home for treatment after she collapsed in the small shed she called home. Her true identity emerged, revealing a past filled with heartache. Adkins was once a pretty blonde-haired woman, trained as a concert pianist. She suffered through two failed marriages, and her life fell to ruin due to bouts of deep depression. Officials put up her two children for adoption; her second husband had her committed to a mental institution. She came to South Florida to live with a disabled sister who passed away, leaving her to cope on her own. Adkins spent her last years at the county home wearing clean clothes and sleeping in her own bed, a vast improvement over her days living as a homeless woman. (Courtesy of the *Palm Beach Post*.)

The Riddle Brothers and the Riddle House

Karl Leon Riddle was West Palm Beach's first city manager, public-works superintendent, and county surveyor. Riddle and his twin brother, Kenyon, graduated from the University of Kansas in 1916 with civil-engineering degrees. The brothers played pivotal roles in real estate and infrastructure development in the 1920s and 1930s. Karl Riddle, chief engineer to architect Addison Mizner, oversaw road and sewer improvements in the city and held several patents, including one for a combination traffic signal and automated pumping system. The brothers' firm engineered the South Lake Worth (Boynton) Inlet and executed the 1927 cut through the barrier island so that clean ocean water could circulate through the polluted Lake Worth Lagoon. In 1935, the brothers planned and developed the 36-acre suburb of Cloud Lake. The two-story house Karl Riddle occupied as city manager is supposedly haunted. Built in 1905 as the Woodlawn Cemetery caretaker's cottage and funeral parlor, preservationists moved the Riddle House, as it is popularly known, to Yesteryear Village at the Palm Beach County Fairgrounds in 1995. Since then, the Riddle House has been the subject of many paranormal investigations. (Courtesy of Jim Pike.)

Judge Curtis E. Chillingworth and the Crime of the Century
Curtis E. Chillingworth was a man of impeccable character, product of one of the premiere pioneer West Palm Beach families. A graduate of Palm Beach High School, Chillingworth graduated from the University of Florida and was a commissioned naval officer in World War I. In 1920, voters elected Chillingworth as the youngest county judge in Florida history at age 25. In 1955, his career and life ended at the instigation of municipal judge Joseph A. Peel Jr.

Chillingworth had admonished his junior colleague on many occasions for his sloppy practice of law. Judge Chillingworth was ready to move for Peel's disbarment for misconduct on handling a divorce. Peel could see his judicial and legal career ending, so he hired two hit men to kill Chillingworth and his wife, Marjorie. Floyd Holzapfel and Bobby Lincoln kidnapped the judge and his wife from their oceanfront home in Manalapan, south of West Palm Beach. The two thugs forced the couple into a motorboat and dumped them into the ocean; their bodies were never recovered. The investigation into their disappearance yielded few clues. Peel's role in the crime remained undiscovered until 1959, when Holzapfel began to brag about the judge he had murdered. Peel, Holzapfel, and Lincoln were arrested, tried, and convicted. It was one of Florida's first murder cases in which a conviction was gained even though no bodies were ever found. State attorney Phil O'Connell said, "The ghost of Judge Chillingworth will not rest until his killers are shoveling coal in the fires of hell and damnation." The State of Florida sentenced Peel to two life terms. (Courtesy of the *Palm Beach Post*.)

The Chillingworth Murders Mastermind
Judge Joe Peel was a frequent figure in nightclubs and bars. His father, Buck Peel, owned a small hotel, and both men were avid golfers. Many people predicted a stellar career for Peel, but one friend foresaw his blind ambition and greed: "He'll end up in either the governor's chair or the electric chair." Released from prison in 1982, Peel died nine days later of cancer. (Courtesy of the *Palm Beach Post*.)

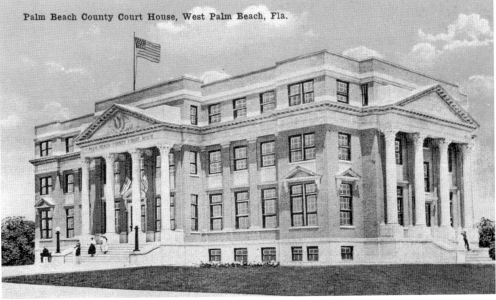

Palm Beach County Court House, West Palm Beach, Fla.

Palm Beach County Courthouse
Judge Chillingworth held court in the 1916 courthouse, depicted here in an early postcard. (Authors' collection.)

Lena M.T. Clarke, Postmistress

A stranger tale was never told than that of the murdering postmistress, Lena M.T. Clarke, daughter of prominent minister Almon T. Clarke. The elderly Clarke parents moved to West Palm Beach in 1909 at the urging of son J. Paul, who was a taxidermist, snake charmer, and hunting guide. Paul Clarke also served as West Palm Beach postmaster, with his sister Lena as an assistant. Paul's death in 1920 from the bite of a coral snake began the downward spiral for Lena Clarke, as her brother was her guide and best friend. A $36,000 bank deposit meant for the Federal Reserve Bank in Atlanta went missing from the post office, and Lena Clarke's theft of the money swirled into a sensational murder. Panicked as authorities closed in on her, Clarke sought help from a former lover, Fred Miltimore, who she begged to take the rap for her. After he refused, she shot him through the heart in an Orlando hotel room. Orlando police arrested her for murder. Lena Clarke became a national celebrity, writing poetry and her autobiography from jail. She went on trial for her life in Orlando. She pled not guilty by reason of insanity and took the stand in her own defense. She testified with her crystal ball about other lives she had lived and foretold that she soon would be vice president of the United States. After only a few hours of deliberation, the jury found her not guilty by reason of insanity. She spent two years confined at the Florida State Mental Hospital at Chattahoochee before returning to West Palm Beach. She lived the rest of her life with her sister Maude, doing volunteer work for her church and the Red Cross. Lena Clarke is pictured at center, with sister Susan Warner on the left and sister Maude Clarke on the right. (Courtesy of the Historical Society of Palm Beach County.)

J. Paul Clarke, Postmaster, Taxidermist, and Snake Charmer

J. Paul Clarke, Lena Clarke's brother, moved to the area about 1895 and worked as a hunting guide with an intense interest in snakes. He collected and preserved snake specimens that the Smithsonian Institution purchased. He appeared in the *New York Times* in 1907 for his rattlesnake fights held in Palm Beach. On his Rosemary Street property, Clarke ran a small private museum featuring his taxidermy work. He died on Christmas Day, 1920, after his gift from the Seminole Indians, a coral snake, delivered a fatal bite. (Courtesy of the State Archives of Florida.)

Pat C Rendezvous, Greyhound Racer

The legendary racing greyhound, Pat C Rendezvous, known to her fans as "Rhonda," was the Palm Beach Kennel Club's star attraction. Born in 1991 and trained by Patrick Collins, the star pooch broke the world record with 32 straight wins at a 1994 race with a record crowd of 7,000 in attendance. The streak ended at 36 wins, which stands as the world record for the three-eighths-mile track. Rhonda was the greatest racer in the history of the Palm Beach Kennel Club. (Courtesy of Sara Mears, Palm Beach Kennel Club.)

Toppie The Elephant, Zoo Celebrity
The Palm Beach Zoo began in the 1950s as Dreher Park Zoo, a small petting zoo within the park. As the zoo grew, local firemen initiated a fundraising drive to buy an elephant. With 1,000 Top Value Trading Stamps books donated by residents and $1,000 in cash, the zoo purchased an Asian elephant. Her name came easy, as Toppie the Elephant was the Top Value Trading Stamps mascot. She arrived at the zoo on April 15, 1965. Due to her increasing space needs and loneliness, the zoo sold Toppie in 1975 to a California zoo so she could be with other elephants. (Courtesy of Greg Allikas.)

INDEX

Find more books like this at
www.legendarylocals.com

Discover more local and regional history books at
www.arcadiapublishing.com